Paint & Grow Rich

How to utilize the art of Business,
in the business of Art.

By
Royston Kieft

Paint and Grow Rich

Copyright © 2009 Royston Kieft
All rights reserved. No part of this publication may be reproduced, stored in a retrieval system, or transmitted in any form by any means, electronic, mechanical, photocopying, recording or otherwise, without prior written permission of the publisher.

Author: Royston Kieft
Edition: 2nd
ISBN: 978-1-921578-86-1

Publisher's Disclaimer
The information, views, opinions and visuals expressed in this publication are solely those of the author and do not reflect those of the publisher. The publisher disclaims any liabilities or responsibilities whatsoever for any damages, libel or liabilities arising directly or indirectly from the contents of this publication.

Printed & Published by BookPal Australia
www.bookpal.com.au

This book is dedicated to the loveliest little accountant in the world...

My dear wife Chrissie.

About the Author

I was born in South Wales and lived most of my early life in the sleepy seaside town of Swansea. One of my aunties was landlady to Dylan Thomas but that was not what first interested me in writing.

As a very young boy I recall my sister begging me to tell her stories as we lay in the darkness of our separate bedrooms. I used to exact payment for the stories by getting her to brave the cold linoleum in her bare feet to bring me drinks of water in the lid of a tooth-paste tin.

Various teachers and even one headmaster encouraged me before I was eleven years old and told me that one day I would probably be a writer.

Before entering tertiary education I worked for five years in Swansea Docks whilst trying to decide between a degree in Art or in English. During that time I became the youngest cargo superintendent in the Bristol Channel area.

For an artistic person the docks precinct was a target rich environment and I did lots of sketching. In the 60's, dock workers earned outrageous amounts of money and seeing my sketches on the walls of my dock office, several of them commissioned me to produce paintings. The first request was for a large oil painting of a ship in a storm. Word went around the docks and soon I was painting portraits of wives and copying famous ship in storm paintings by Turner and others.

In 1966 I enrolled at the quaintly old fashioned

Swansea Art College.

Having already sold some oil paintings I was eager for some professional tuition. I still remember with affection the hallowed Victorian halls of the old stone and brick building and its ambience of craftsmanship, turpentine and linseed oil.

I was disappointed, however, to discover that art students were not encouraged or even allowed to paint like Turner or Gainsborough or Renoir but to churn out 'modern art' so that they might understand good composition and colour balance. I dutifully followed the rules of the game until I got my place at Leicester College of Art. There the draconian abstraction regime threatened to make me quit art college altogether. Fortunately, I made friends with a scrap merchant who specialised in reclaiming War Department electronic equipment. With his help I turned my back on painting and began building light and sound machines and interactive environments, and writing articles for magazines and newspapers in my spare time. Whilst at Leicester I got married. From Leicester I went to the Royal College of Art. The department of stained glass was being *re-engineered* as the department of Light Transmission and Projection. They viewed my amazing modern art, electronic constructs as just the sort of thing that they were looking for to metamorphise their most medieval of departments; Stained Glass.

At first I was just having fun, the Imperial College of Science and the College of Mining Engineers were two minutes walk away and to cut a long story short, whilst at the Royal College I started my first revenue earning, art enterprise; **Obadiah's Gasworks**. We hired

ourselves out to any rock groups that could afford us and provided light shows on some of the best known stages in London.

We shared a house with Brian Eno and some members of the rock group, 'The Who'.

Life was glitzy and blitzy but when our first daughter came along I decided to sell my Jag, quit the pop business and studies in modern, psychedelic art. We moved back to Wales and I enrolled in a post graduate course at Cardiff University and became an art teacher.

I had learned a great deal in London about making money and it wasn't long before I was supplementing my teacher's salary with business ventures. A new daughter arrived and for some years we were a happy family of four.

I won a British Design Council Award, a scholarship to Durham University Business School and founded a manufacturing company called the Miniature Brick Company Ltd. With this company I won first prize in a national business competition for companies with under 200 employees and began appearing regularly on television.

I was selected as a small-business person to join the CEO's of the top 6 British companies (Including British Aero Space and British Telecom) for a two week, residential intensive business course at a posh hotel and convention centre in the Wye valley. We had six Harvard Business School professors helping us day and night for two weeks to hone our business acumen.

Most of my friends and acquaintances at this time saw my life to be really taking off. All was not well

however, in fact disaster was overtaking me on all sides. My business partner was quietly swindling me and my wife was following her divorced friends down the "separate lives" path. Ill health and the loss of practically everything I held dear destroyed my interest in running a business once divorce papers had been served.

In the dark months following I went back to an earlier love of mine; painting. I took what I had learned from my business career and applied it to the problem of earning money as an artist. As a result I went from making about $600 for each painting to $10,000 for each painting. I did so in a matter of months.

I remarried and now have eight daughters from the two marriages and am still happily married after almost 25 years with my second wife.

We migrated to Australia in 1990 and I taught marketing and product development at the Australian Business College for three years and served as chairman of the Australian Design Council.

At a recent seminar a young woman artist rose from the audience to take the roving microphone and stated that as an artist and a good artist she couldn't make enough money to pay the rent and eat, could anyone advise her.

That was what jolted me into writing the book "Paint and Grow Rich". The title is somewhat euphemistic in that we all know that it's not how much one earns that makes one rich but how much one keeps to invest and to create more income. That is what can lead to the accumulation of wealth.

I am currently teaching Art two days a week,

studying for a degree in Naturopathy and learning how to practice Tai Chi. I have a series of six paintings currently on the go which will be controversial when finished and, I hope, very lucrative.

The problem of turning a good income into lasting riches is addressed in my next book entitled **Right to Riches**.

Contents

Chapter 1: Art before food ... 6

Chapter 2: How much is your life worth?................................. 13

Chapter 3: Reframing... 19

Chapter 4: Turning photographs into paintings. 28

Chapter 5: The game plan ... 43

Chapter 6: My first $10,000 painting... 57

Chapter 7: The Local Bowling Club .. 79

Chapter 8: The School Centenary Print 92

Chapter 9: From Selling Prints to Publishing Calendars. 99

Chapter 10: Candle Making; Making an Income to Support Your Art... 112

Chapter 11: Metalkits; Turning Metal Sculpture into Gold . 121

Chapter 12: Toad Hall; Keep your Cards Close to Your Chest .. 135

Chapter 13: The Miniature Brickworks; An award winning business.. 139

Introduction

If your current bank balance accurately reflects your intelligence, skills and creativity, you may not need this book. If, on the other hand it doesn't and you do what this book teaches, excitement and plenty of money will flow from the use of your creative gifts.

Rembrandt became a millionaire in his life time. Vincent Van Goch, whose brother was a gallery owner, successful businessman and loved his brother passionately, failed to make anything except losses and debts from his work. Both Vincent and Rembrandt were geniuses at painting. The work of each of them, today sells for millions.

Why am I telling others how to make money from painting?

I was recently at a motivational seminar. During a sharing session an attractive young woman rose to her feet and told the thousands of others in the audience that she was an artist and she reckoned a very good artist but that she could not earn her keep and buy a house and go on holidays by painting and selling her work.

That emotive confession actually spurred me to write this book on how I have made a good living for decades using creativity combined with some simple

business tactics.

I stumbled upon a formula for making money from artistic creativity when I was down and out and practically bankrupt from a business failure. This book is an account of how and why I began to make money from art.

Consider the fact that around 2% of the population have the artistic gift that you and I are blessed with. There have got to be ways to successfully market such a rare commodity.

At the end of the book I will invite you to send me an outline of the type of work you do so that between us we can tailor some ideas and a working plan for you.

I wrote this book for someone like me. I wrote it so that other artistic people don't have to go through the stuff I've been through in order to learn how to become an artist who earns a good living from their work.

Crises are opportunities in disguise.

In 1985 I lost a thriving business and a family before I discovered how to make money from painting. I felt like a broken man. I was too ill to work at much, but I new I could paint. I had never before thought of making a living by painting. Let's face it, who does?

One day, almost miraculously, whilst trudging along a busy street I found a brand new, top of the line box of water colour paints lying in a plain cardboard box on the pavement!

At that time I would not have had the nerve to spend what little money I had left on paints, so I took

this find as an invitation to make a living by painting and I was then mentally able to give myself permission to make money from my gift.

Often it is not that people can't make money. It is much more that they don't feel that they have the right to and won't give themselves permission to make money.

Within a couple of years of making a decision to believe that I was being prompted to succeed, I was earning tens of thousands of dollars from each painting I produced!

If you are saying to yourself *'I could never paint something worth tens of thousands of dollars',* maybe you are right! But I didn't say my paintings were *worth* tens of thousands of dollars I said that they *earned* tens of thousands of dollars and I will show you how you can allow your work to earn really excellent money too!

Anyway, congratulations, you have taken a vital step towards turning your paintings or your sculptures into gold. You have notified yourself and your universe that you are serious about getting rich through your gifting. Something has prompted you and if you set your heart on it now, then you will succeed.

This is not a book on how to become a successful artist per se. It is merely about the art of Business in the business of Art, or: How to turn artwork into gold.

We learn from mistakes. Other people's mistakes are really good to learn from.

You will be happy to know that I have made many mistakes.

I have also discovered many, very practical ways of turning a piece of Art into an ongoing income stream.

If you are a reasonably competent artist then this book can help you turn your work into bankable money. You may prefer other forms of art to painting. The chapters at the end of the book give detailed information about creating an income from a variety of artistic activities, even metal sculpture.

So read this book and try to feel it. Engage emotion to make the learning stick.

Some of my business friends who didn't know me when I was hard up, are going to be shocked when they read how clumsily and primitively I began to extract money from my work and how many dumb mistakes I made before I discovered and began to use 'the art of **B**usiness in the business of **A**rt.'

I am not proud of my mistakes. I've left them in for you to see and learn from. When I found making ends meet hard to do, I used to say; *"Well, no one can be good at **everything**,"* That, my friends, was a cop out. In the modern world you have to get good at making and managing money as well as making art.

Being good at everything else is great but it will get you nowhere without money. There are too many ragged geniuses around already, don't swell that number.

My first wife used to tell my friends with a groan, when ever my business hit a patch of trouble, "Roy can make anything, except money".

That may at the time have been true, but when I was completely down and out and only had the strength to do a bit of painting, my plight focussed my mind. I began to figure out ways to survive by painting and then how to thrive on it.

I used to fear that having plenty of money made people mean. That doesn't have to be true. The creative, entrepreneurial, college drop out par excellence; Bill Gates is living proof that money needn't make you mean.

At first, when I began to make large amounts of money from my paintings I lost it all again very quickly.

Take a millionaire's money and give it to a poor artist and guess what happens?

The millionaire soon makes lots more money and the artist soon loses the millions given them.

There is more to getting rich than getting money.

So check out the illustrations that are on my website. (I put them there so that you didn't have to pay for printed versions when you bought my book.) Follow the account of how I gradually stumbled upon a formula for making good money from reasonably competent art work and begin to make money yourself.

It doesn't matter if one or a million artists use my book and my formula there is a growing market and no amount of artists can saturate it.

With the internet and the advent of immensely powerful personal computers it is much, much easier to make money from art today than when I began this journey 25 years ago.

So be brave and have a go; you owe it to yourself. As you succeed you will encourage others to succeed and you will never need to be in competition with them.

1

Art before food

In the 19th Century there was a terrible lot of guff bandied about, to do with the artist starving in a garret. These colourful myths were inspired by the weird and wonderful thinking and crazy lifestyles of geniuses like Vincent van Goch.

Vincent was no doubt a brilliant painter. His lifestyle, however, was self destructive in the extreme.

When I was at the Royal College of Art in the late sixties I rubbed shoulders with many a brilliant art student who conspicuously practised the art of starving for their art. (OK, I went to an Art College but I honestly didn't ever consider supporting myself and a family through art. I didn't consider art as an earner until I had nothing else left that I could physically do.)

It seems that Van Goch and his mates invented this "starving for Art", idea just for the modern artist.

Since the 19th century, would be artists have developed the ragged life style to perfection. 'Art colleges for the masses' and not just for the landed gentry created a proliferation of hyper aesthetic art students who have cemented society's belief that money and artists do not mix.

You are reading a book that is designed to make you wealthy through your art, so hopefully you have realised that all of this poverty posturing is a load of pooh and that real artists have always been in business

for themselves; admittedly some more effectively than others.

Rembrandt made the equivalent of millions whilst he was alive. He died a pauper through bad management and infidelity but now that he is dead his work makes even more millions. It is worth millions because it is unique and genuinely verging on the miraculous.

Cezanne's dad was a banker and wanted his son to continue in that very lucrative family business. He could see that his son was a less than brilliant technical artist (take a look at Cezanne's earliest work if you don't believe me. One look is bound to encourage you.)

His Dad must have been a very indulgent parent because he allowed the young Cezanne to leave the family bank just to practice getting better at painting. He worked at the bank on and off when people were so rude about his work that he felt like quitting.

Such was Cezanne's resolve to paint however that, funded by his family he eventually became, perhaps the most influential 19th century French painter in the world. So there is hope for us all. Don't forget though, that he needed the money to do it. Without money you can't really make a career out of painting.

What about starving Vincent, did he have money?

His successful brother Theo supported Van Goch. Theo couldn't give Vincent too much at a time because this poor artist was in the habit of giving everything he owned away whenever he got depressed, which was regularly.

Check the crows in the cornfield painting, or the self portrait with one ear missing to get an idea of how

depressed Vincent could get. When he got really depressed he would cut bits off himself and give them away to people whom he wanted to impress with how depressed he was!

So Vincent's brother, Theo, was never mean but was very careful not to give Vincent too much money. He usually bought all of the paints and stuff for his artist brother and provided enough cash for a bit of bread, an occasional bucket of water and a private room in the picturesque lunatic asylum in Arles.

Don't get me wrong here; I love Van Goch's work, he is my favourite of the 19th century French painters. (Yes I know he was Dutch but he knocked around with most of the French impressionists, so he is my favourite of that mob.)

I also know that Theo loved Vincent dearly because I read their letters (published in two huge volumes) when I was a student. At the time those letters totally put me off the idea of painting for a living and so until a massive personal disaster struck me, I never considered it.

I recovered from losing a successful business, a family, et al, to begin making good money from my reasonably competent painting, almost by accident. I will tell you more about that later.

I've read nearly all of the motivational books too. One time I had an epiphany that might interest you, I realised after reading my tenth brilliant book of that year (there have been plenty of them; books and years) that you don't really need to read them *all*.

I realised that keeping on reading motivational books was not actually changing my behaviour. It was

just making me more knowledgeable and more certain that I was doing a lot of the wrong stuff.

Motivational books never gave me a step by step process for putting things right, particularly in my chosen field of endeavour; *living by painting*.

This book does, eventually, give you step by step instructions on how to make thousands of dollars for each piece of your work you choose to use as an income generator!

As I have mentioned though, getting lots of money doesn't necessarily make you rich. The comprehensive preliminaries in this book are vital in that they can engender the optimistic state of mind necessary to allow you to move from artist, to rich artist.

I did make the following important discovery whilst reading the motivational books.

Read one of the many marvellous motivational books, do what it says, re-read it and go on doing and believing what it says and your life has got to change for the better.

Sadly, not one of the books I had read was specifically designed for an artist, so when my accountant (2nd wife) helped me make some of the simple changes such as those recommended in the general motivational books and regularly reminded me to actually do the right things, everything began to work out and I began to keep some of the money I made from my painting.

Write this on your bedroom wall in large red letters:

It is not how much I earn that will make me rich. It

is how much I keep!

You don't have to be mean to keep some of your money. Just don't swap it all for a load of stuff that is making someone else rich.

Remember that a fool and their money are soon parted. This will always be true!

If good motivational books don't do it for you, marry an accountant!

This book is a motivational book with a subtle difference; it is for you and for *me*, the artists. (I say '*me*', because artistic types must regularly return to the basics about getting rich and that includes *me*.)

It is not a generalised book, though much of what it contains may be used with projects other than art projects.

I am still using the stuff in this book.

This book can, if you simply do what it says, make you into a rich artist and do it in breathtakingly quick time. Try not to pooh-pooh the idea or be afraid to believe it, until you have read the entire book at least once.

You will know you are getting somewhere when this book begins falling to bits!

If this was a book on building a boat and you started building a boat in your back yard, how would you use the book?

The book would be battered by the time the boat was finished. It would be dirty and worn out, probably stained with resin and falling to bits!

By the time you are making $80,000 a year from your Art work, this book should look like it's been well used. Check its condition occasionally. It might give you

a clue as to whether or not you are actually using what you paid for.

So clear out your book case and focus on what this book teaches and begin to make a lot of money in a remarkably short time. Doing what this book says will buy you all the free time you need for producing great work.

You don't have to read this entire book lots of times. There are specific sections that detail how to do something, like selling a painting for a lot of money for example. Each of those sections needs to be taken out of the book or copied and then followed like a manual.

Don't be afraid to cut out pages and make flash cards of them. You are not going to turn into a rich artist in one reading. You have been practising doing the opposite for years and it is going to take a little while to turn your boat around.

Actually, I love boats, especially boats that need a bit of work.

So what have we looked at so far?

1. Admire Vincent's work but be warned by his lifestyle.
2. Manage your life and money better than Rembrandt managed his. Be encouraged by looking at Cezanne's early work. If he could become world famous you should do ok too.
3. Focus on this motivational book with all your energy.
4. Change yourself and thereby change the world you inhabit.

5. It is how much money you can keep, not how much money you can earn, that will make you rich.
6. Use this book like a boat building manual. Use it!

2

How much is your life worth?

You have probably been selling your time all of your adult life and possibly, to date, for hundreds of thousands of dollars, but where has it got you? Did the crafty buyers get your life cheaply?

Don't get even, get angry! I'll say that again in case you think it was a mistake.

Don't get even, get Angry!

Get angry with yourself, not with the buyers of your precious time! At least they helped feed you.

You sold your time cheaply! You stopped yourself having the time to paint or sculpt or what ever. Get angry about it!

Not only that, you, (like I used to), got rid of all of the money you earned, pretty well the week or month you earned it

I certainly remember trying to work on creative stuff in my spare time. It used to make me so cranky if I wasted a precious minute of that spare time. My life was miserable and totally stressed out.

Actually there is no such thing as spare time. The world is a wilderness of weeds and thorns that cling to you and prevent you from working creatively.

You have to make clearings in your world. When you sit in the clearing you have made, you get some free time. Then you have time to create.

It seems like an oxymoron to say so, but free time has to be bought and paid for.

The saying that; 'time is money', can be turned on its head to say that 'money is time'; free to do what you wish, time.

Chapter 6 of this book shows exactly how you can sell just one of your paintings for $10,000! How much time will $10,000 buy you for your more ambitious and creative projects?

Plenty!

The less than happy thing about working at a job is not necessarily the work itself. It is the lack of freedom. It is the constraint that you have to be there and do what you are told.

Some jobs are better than others but creating your own way in the world is what you and I were designed to do. Creative hearts thrive on freedom.

When you start to bring in some real loot from your art, be aware that you might have been conditioned by years of working at a job, to see the healthy bank balance as an opportunity to slack off rather than to thrive.

Find a healthy compromise between leisure and work.

A family I had known quite well from my childhood, a normal working family, won $2.9 million in a lottery. Suddenly they thought they were rich. Sadly that was not true at all. They had the money but not the management skills they needed.

It took about four years for them to lose all of the money, get into more debt than they had ever been in before and then have to re-mortgage the beautiful house they lived in and had recently paid cash for.

Effectively they were back where they had started but the experience of using all that money had not been a happy one.

As you start to earn lots through your art, either get cosy with a really good accountant or get hold of some financial literacy for yourself, because you are going to need it.

"I could never paint one painting and sell it for $10,000 whilst I was still alive. I'm not even sure that my work would be worth that after I was dead."

I knew you were going to say that!

This book is called 'Paint and Grow Rich' because that is, apparently, a more eye catching title than the 'Art of business in the business of art.' Nevertheless I am going to show you exactly how a business man/artist approached the problem of making money from his art, (mine).

I did it in very simple but crafty ways. No one was ripped off, everybody won and I got rich and so will you. So trust me and read on.

Get into the habit of believing that you are a rich artist, you just haven't got the money yet.

You are going to get the money, believe me! When you do, I will encourage you through my website, to plough a little of your profits back into your mind by acquiring even faster ways of making money through art.

So how does a rich artist feel? What plans do they

have for a studio? Which galleries do they plan to visit world wide?

You are on your way to becoming rich through your work so get the feel of it. Start to walk and talk and think like a rich artist. You don't have to brag about something that is not yours yet but you do have to cultivate an inner sense of destiny. You need to live rich in your heart and your mind before you become rich. Being rich takes a lot of skill.

Take a bit of time each day to plan exactly how your studio will look. Add a bit of detail each day.

Think about travelling to Rome or Venice or New York, meeting other artists, studying famous works of art in the flesh.

Don't be alarmed, but in a rich western type society, poor people make sure that they stay poor, just as certainly as rich people try to do the opposite.

If that sounds crazy to you, I understand. However you had better believe that your heart and mind need to become rich, feel rich, think rich and plan and speak rich and expect to become rich before the money arrives.

Where you heart goes your feet will follow.

(There is a way for you to change the whole world; change yourself.)

I may be labouring this point a bit but there is a mental ravine you have to cross in order to truly prosper.

As an artist you have an amazing secret weapon in this fight you are having with your prior conditioning. You are very good at visualization.

I'm sure that you have heard that old chestnut about the little elephant, tethered by one leg to a stake

driven into the ground.

In case you haven't; even when the little elephant grew big and very strong it wouldn't free itself from that same little stake.

A great deal of what this book is about is helping you to free yourself. Desperation forced me to free myself. I am hoping that you will allow inspiration to do it for you.

Inspiration plus the ability you already posses; visualisation, will initiate change.

Much of this book is an anecdotal account of how I discovered and crossed my mental ravine. There are some good stories that may not look like lessons, but I learned from them and I am guessing that so will you.

Not all of the ideas in this book bring $10,000 from one painting. Some bring less money and not all of the ideas are about bringing income from just painting.

Even if you only get $5000 the first time you try the $10,000 strategy don't see it as a failed effort and stop there, repeat the process with another painting. The second and third times are always easier and more productive than the first.

Get good at one technique for exciting people about your work before you move on to others. Once the money starts to roll in, confidence will no longer be a problem, complacency might though.

When you haven't had much money lying around, $10,000 seems like more than enough. Don't be greedy but believe earnestly, angrily, for what you are really worth.

If I gave you an accident insurance policy that would pay you every time you damaged yourself, how

much would you hope to get for the loss of an eye?

Put it another way, if I offered you money for your eye what price would you set on it?

Try the same calculation with an arm or a leg. You and I are worth a lot of money but we sometimes treat ourselves as if we are worthless.

You **know** you deserve a lot more than you are getting or you wouldn't have started to read this book.

So what did we look at in this chapter?
1. Don't get even, get angry that you sold yourself short.
2. Generate income and buy yourself time to develop as an artist.
3. Don't slack off when the money begins to roll in.
4. See and get to know the rich artist that is captive and waiting to be released.
5. Use your secret weapon; visualisation
6. Rejoice in confidence but beware complacency.

3

Reframing

There is an almost infinite pool of money out there waiting to be tapped. I have designed for you a range of taps. You just plug them in according to the instructions and turn the tap and let the money flow into your life and your work.

Always remember to give some of it back. Don't let money get you and corrupt you. Regularly give some of it away. Giving is a great antidote to some of the more negative aspects of becoming rich. Just do it! (Nike paid someone a pile of money for that slogan because it is very worthwhile evocation Making lots of money is very easy if you do stuff not just think about doing stuff.

Success will then breed more success if you just keep at it.

'Think and Grow Rich' was a world famous, best seller by Napoleon Hill that helped hundreds of Americans and later on persons of other nationalities to become millionaires.

That book taught people the art of reframing a problem and thereby solving it with new vision.

At the moment you probably have that old picture in your head of you holding out one of your paintings to a sceptical purchaser and the prospect deciding *not* to pay you $10,000 for it.

Even when you have successfully earned $10,000

from one of your paintings, you will still find it hard to believe.

Believing takes practise and believing gives you the power to succeed.

You've only just started reading this. Your perception of turning art into gold is probably still wrongly framed.

This book is written in the order it appears for very good reasons. If you can't contain your curiosity regarding how it might be possible for you to earn $10,000 from one painting, then read Chapter 6. By the end of that chapter, you will be convinced it can be done successfully by any reasonably competent artist including you, time and time again.

When you have read Chapter 6 and are somewhat convinced that it is not impossible to get lots of money out of just one painting, turn back and continue reading from here the. The early chapters will help create a frame of mind that will enable you to enjoy making lots of money from your work.

If you will believe and trust and do what it says, then this book will make you thousands and thousands of times what you invested in it. It will change you into a rich artist if you really use it. See it as a manual on building a fortune. Don't try to do Chapter 6 without allowing the preceding chapters to talk you into giving yourself permission to succeed. Okay?

Geniuses are not clever at making money.

At this point I am assuming that you are reasonably proficient at painting. You don't have to be a genius to make money. In fact geniuses are the least capable people when it comes to making money. They

are usually too preoccupied!

If you are wondering if your painting is good enough to make money and you want a few tips on commercially successful, water colour painting or oil painting, read chapter 4 on how to turn digital photographs into paintings and how to turn those paintings into money.

I was once a student of Edward De Bono before he became world famous; this was one of the problems he posed for potential entrants to his class.

Trust me. I am sharing this to get you into the necessary state of mind to absorb the practical stuff that will guarantee you a large income.

You and I both, want you to reap a good crop from this investment of money, time and effort you are planning. This part of this book is conditioning the soil, prior to planting excellent ideas, as you are reading it.

My reputation and your future wealth depend upon my being able to get you, to use and believe in the stuff that is in this book. That will take a little patience and preparation.

Fire fighting

A group of scientists was charged with the task of obtaining and analysing soil samples from the top of a particularly remote kopje in the South African Veldt.

There was only one practical route up this drum like outcropping. The sides were vertical and the top was oval and quite flat, with a very slight slope. There was just one crack in the defences of this 600 foot high

Plateau. During the rainy season water gushed down a fissure in the vertical rock wall and over millennia had created a narrow chimney all of the way down to the bottom of the cliff.

With a stiff, hot breeze at their backs the scientists scaled the crack in about three hours, had a brief lunch at the top and then set off to explore the kopje.

The soil of the plateaux was remarkably fertile and supported a strong growth of savannah grass that was shoulder high in most places.

The scientists had not moved more than a quarter of the way across the top of the kopje when they smelled smoke. Turning they were alarmed to discover that embers from their charcoal cooking fire had started a blaze at the point where they'd had lunch.

A solid wall of flame and smoke was spreading across the flat grassland and racing up the slight slope towards them.

What could they do? All the sides of this volcanic outcrop were vertical. The only way off the kopje was the crack they had used to climb it and the fire was going to consume the entire grassy top of the plateau.

All of the information you need to solve the problem and save the scientists, exists within the story so far written. So just for fun, have a go at solving the problem for them. Don't feel in anyway condemned if you don't succeed. I just want you to see that when you re-frame a problem, perfectly usable answers become clear.

At first it looks an impossible problem to solve, like selling a painting for $10,000 may, but actually the

solution is quite easy to do and to comprehend. Life is a bit scary and in the stress of the moment it is easy to miss an obvious solution to a problem.

To recap: the scientists had built a charcoal cooking fire when they'd reached the top of the crack and subsequently neglected to make sure that every last spark had been doused when they'd left to explore the plateau.

The wind must have gusted and blown some embers into the shoulder high dry grass that covered the entire top of the kopje.

We know therefore that the scientists, even if none of them smoked, had fire making materials. We know too that the hot breeze was blowing the blaze towards them and that they were likely to become engulfed because there was no other way off this elevated, oval grass land other than the crack they had first climbed.

To get out alive required no miracle; the scientists in the story had to do something apparently silly; light another fire right where they were standing! As the breeze blew it forward they merely walked behind the fire they had deliberately lit, as close to the flames as was bearable.

Both fires atop the kopje moved at the same rate, propelled by the same wind. When the threatening fire behind them reached the deliberately burned grassland behind them, the fire went out and they were able to walk back down the slope, through the still smouldering ashes, to the exit crack.

QED

This book, "Paint and Grow Rich" contains simple but effective ways of re-framing the process of obtaining

income from creative activities such as painting. It does not require any miracles.

Don't think it will take you any longer than it took those scientists in the kopje story to turn a problem around.

It took me only about eight weeks to get $10,000 from a painting, once I had applied lateral thinking to that business problem. To do so I actually sold the original painting in its very expensive frame for a mere $10 (like the scientists, I did something apparently silly). You could do that. You could sell a painting in an expensive frame for $10, right?

If I told you how to do it right now you might not have a serious go at it, so forgive me but we must get to that a bit later.

Remember I had spent decades in business, never once thinking that painting pictures could make me much money before using what I had learned to extract money from my art.

Trust me, we will get to the $10,000 per painting bit, but you need a bit of preparation first to make sure that you have seen and understood and absorbed on a subconscious level, all of the thinking that went into that simple but devastatingly effective strategy.

Look at it too soon and you won't see it.

Do you remember the 'Magic Eye" pictures that were all the rage a few years ago? They looked like mad computer doodles. When one first looked at them they were meaningless. When, having been persuaded by other people's enthusiasm (usually youngsters), one looked at them for a long time, a totally three D picture emerged from the apparently formless mess!

Having seen it once and achieved some confidence, other prints in the same vogue became quite easy to see after a few moments of staring.

Reading through this book may sometimes be a bit tedious for an artist. Any rich artist however, will appreciate the mind frame that is being cultivated through this story of false starts, dead ends and then overwhelming triumph.

Business, what is it?

A bit of courage is indispensable in the world of business. You have to decide how much money you want and then go and claim it. Most workers prefer to trust that someone else can bring home the bacon and will then shave off a few rashers for their workers and for their services; (being such a worker is called holding a job).

Working for yourself, you bring home the bacon; this is called self employment.

Getting others to do the work that you organise for them to do and reaping the rewards of your creative and lateral thinking. That is called a business.

These days you can't even trust banks and governments to look after you or your money.

So start right now, planning for a future where you say what you will do to make a living. The only person then who will determine the level of your income will be you.

I have banking friends who have always looked upon my lifestyle as precarious. Several of them today,

for no reason other than that they unwisely trusted their employers to always employ them, are very short of money.

As an artist, you have a distinct advantage. Compared with the average banker, you know what lack of money is like, so it can't really scare you into always being scared not to work for someone else. The unknown is always more frightening than the known. If, as I suspect, you are like me, you already know what not having enough feels like and can handle it, temporarily.

No one employs *someone*, unless that *someone* is earning more than *they* are getting paid. Think about that!

You are an artist who has survived so far and is now about to learn some marketing tricks that will bring in the cash.

Don't forget to keep a lot of it and use it like seed to make more.

Better still marry an attractive accountant and chill out.

So what did we learn in this chapter?
1. There is a story to follow here and it is designed to help change the picture you have in your head about money, art and you.
2. You have to learn how to give yourself permission to become rich.
3. Reframing a problem reveals the opportunity that, that problem contains.
4. Be prepared to do some apparently silly stuff,

(counter intuitive is the current jargon).
5. Remember that truly busy business people do not work for money.
6. No one pays someone to do work unless that someone doing the work is earning more than they are being paid for doing it.
7. Like the weird 3D pictures there is a counter intuitive element in the process of making money. Re-routing your ability to visualise more effectively than the average person can help you to step into a much higher tax bracket.

4

Turning photographs into paintings.

These days anyone can become a master photographer. Anyone, that is, who has at least some artistic sensibility can become a master photographer.

Let me repeat part of the first statement: "These days anyone can become a master photographer." It is true!

Digital cameras, with amazing abilities to take photographs are available at remarkably low prices.

With a modicum of computer awareness one can take a digital photograph and modify it until it perfectly suits the purpose for which it was taken.

Even relatively cheap digital cameras can automatically stitch frames together to produce flawless panoramic shots! The number of mega pixels per square millimetre is rising exponentially. Even my phone has four times the mega-pixels than my first digital camera had, for goodness sake!

My first expensive, 'high end', digital camera was a four mega-pixel wonder and cost in excess of $1000.

My second decent digital camera, with many more features and 12 mega-pixels cost just $650!

It's not really the mega-pixels, nor the clever stuff the cameras can do these days that makes the big difference however. What really counts is the number of

photographs you can take for practically no cost at all and then be able to examine results immediately.

When I first took up photography, to be sure to get the perfect photograph of an important subject I used the expensive method of bracketing exposures. That is, taking several shots of the same scene, from the same spot, with a variety of exposure settings and then picking the best one.

The cost on a day's shoot was therefore quite high as every shot cost me for film and for processing and printing, even if I didn't use those shots later.

This was a factor that had always weighed on my mind and restricted my photography.

These days, if one so wishes, one can take a bracket of exposures and get the computer to combine the best of the shadow detail with the best of the highlight detail and also create a print that is in focus from close up, to infinity. Beat that!

Another problem was camera shake, poorly focused shots and slow reaction times on the part of the photographer and camera. Everyone used to have at least one totally empty and blurred shot of the dog that had run or the bird that had flown, just as the shutter had clicked.

In those days the perfect shot had to be taken by a heavy and expensive camera, on film that ran out after twelve shots! You could stretch that to 24 shots by using 220-film.

That is if you were brave enough to use 220-film. You needed the dexterity and nerve of a bomb disposal expert to complete the tasks involved in unloading and developing 220-film successfully. On top of this, the

camera had to be set in concrete to get crisp photos.

Today's ultra fast, image stabilised, red eye eradicating, automatic focus and exposure controlling, wonder boxes that even track what your eye is actually interested in and looking at and make that the primary focus, are very difficult to confuse. These days, perfect shots are the norm! Aside from the unlikely event of the photographer being struck by lightning whilst an earthquake of magnitude 7 on the Richter scale is tossing the subject and the photographer about, you will get a good snap.

Composition, well if an artist (you) can't compose a shot, who can?

Just the other week, I went to Fremantle to take some photos for a series of paintings I had planned. For just one painting, I counted that I had taken 97 photographs! When closely examined not even one of this batch was totally what I wanted. The display of these shots on my computer told me however, exactly how to take the next few photos to get precisely what was required by way of visual information.

So that same afternoon, I left my computer and went back and got the few extra shots I needed and they were spot on. I prefer the studio environment, onlookers embarrass me and take my mind off what it is I am trying to achieve.

In the old days, that 'shoot' of 97 photographs, would have cost me a fortune, required fiddling with lots of film loading, and taken a couple of weeks of development, printing and re-shooting. I would, in all probability, have settled for a compromise, a shot that was almost good enough.

So with a decent digital camera or mobile phone you can definitely capture what you want and do that immediately.

I learned one or two things from practising and teaching old fashioned film photography that may still be of assistance to someone new to the art of the snap.

Shots of buildings need to be taken with the camera absolutely horizontal. That is parallel to the ground. If the top of the subject is too high to fit into the viewfinder, tilting the camera to get the whole of the building into the one shot will cause serious distortion. All vertical lines will tend to converge. They will seem to get closer together as they reach toward the sky. To avoid this, old cameras had rising fronts. You, with your digital, can take lots of shots, high and low but only with the camera held absolutely horizontal. You then stitch the pictures together. I'll show you how shortly. Portraits taken with a normal or wide angle lens can be less than flattering. In 35mm terms that would be focal lengths of 55m down to 28mm. The optimal lens for portraiture is a long lens, slightly telephoto. On 35mm cameras that would be 80mm or 90mm. When you are using a 6cm by 6cm, medium format camera, that would be a focal length of 180mm. If your digital camera doesn't give you much info as to the focal length of the lens at any particular setting then opt for the telephoto setting that is half way between the default, or normal setting, and the full telephoto. A bit of practice, now that you know what you are looking for, will soon sort this out.

Depth of field is a term that means how much of the scene being photographed will be in sharp focus.

The depth of field is determined by the aperture or the size of the hole, the light is allowed to travel through as it passes through the lens. An easy rule of thumb to apply, to successfully control how much of your photograph will be in sharp focus is: the slower the shutter speed the more of the shot will be in focus when you hold the camera steady. At faster shutter speeds less of the photograph will be in focus but camera shake becomes less of an issue. If your digital has a sport or action setting this will be the latter, wide or landscape will be the former.

What do you like to paint or sculpt?

I'm assuming that, like every serious artist before you, including Picasso, you realise that nature and the fall of light on various subjects has quite a bit to teach you about that illusive quality, beauty.

Invention and abstraction and breaking new ground and any of the exciting and innovative things that artists can do, benefit immeasurably from a genuine study of what looks lovely and what looks right and why it looks right.

Even if shock and awe is what you are into, you can check out El Greco's firing squad pictures from the Spanish Civil War. El Greco learned from nature, not just human nature, how to make great paintings. If you want shock and awe to the max, check out the work of Francis Bacon, he learned a lot from El Greco and that made Francis into a very famous modern artist.

For me, to paint even something as random as a windblown sand dune, becomes a challenge to my integrity. There are natural forces at work here that make the sand dune's shape exactly the way it is and no

other way.

The size of the grains of sand, the surface and geometry of each grain, the dampness of the atmosphere, the strength and turbulence of the wind and the heat and direction of the sun, all have very precise effects upon the shape and steepness of the sand dunes. All of these forces sculpt and build a most particular and beautiful set of shapes. Every angle is a logical outcome dictated by other angles and curves etc.

Dunes are never actually random but are the exact and predictable outcome of the various physical constraints and characteristics mentioned above.

Witnessing the effortless power of nature to sculpt, with breath taking beauty, giant dunes of sand, humbles me. No two dunes are the same yet each is perfectly correct, perfectly, naturally formed in accordance with the forces at work on billions of grains of sand.

I would never try to invent a sand dune in a picture. I would have to study and see what was there, understand to some extent why the dune took its particular form and then, maybe, try to extract an abstract of that formal beauty to use in a composition.

Invent a sand dune without reference to nature and the result must be second rate at the very least or a Frankenstein at worst. The resulting invention will be less than excellent because the beauty of the thing is in the truth; that its form, though transitory, is inevitable and the result of natural forces.

Humans are much easier to learn to paint well, than sand dunes. Bone structures are well documented and grow, within certain parameters, fairly regularly. They are encased in muscle and fat forms that have

developed under the influences of gravity and exercise or lack thereof. The more mystical and illusory features of the human form however, are related to the mind rather than the body. Like the sand dune's inscrutable beauty, the smile on the Mona Lisa's face is transitory and hard to capture. Her physical face is easy to replicate but a certain smile can only be caught by the artist who some how knows from whence the smile is derived.

I bet you wish you hadn't started reading this bit, don't you!

Seriously though, when I take my camera out and then come back to my studio and begin to decide what to extract from the visual information I have collected, I know that a large part of the painting will relate to the atmosphere I experienced on the spot.

Absorbing atmosphere and then imbuing a painting with that same illusive quality is something I can't teach. You either have it or you don't.

How to turn photos into paintings

What I *can* teach, however, is how to make the best use of your camera and how best to turn photographs into paintings.

Even a low mega-pixel camera can be very useful for the type of work we are discussing.

Clear details are absolutely critical. I take a general view of my subject and then close in and take a patchwork-quilt-spread, of close up shots of the important detailed areas.

If the general shot captures the main outline of what you want to paint then the following procedure will help you to transfer all of the important positional details to the paper or canvas in preparation for the painting.

Make a photocopy of the photograph of the general shot and make it the size you want the painting to be.

Turn the photocopy over and with a soft pencil; 2B, scribble over the back of the photocopy. (You are thus effectively turning the photocopy into carbon paper.)

If you tape the photocopy to a window or a light box then the details show through and you can more easily concentrate your scribbling on the areas of detail and the particular lines you wish to reproduce.

Once the scribbling is complete, tape the photocopy face up to the surface upon which you will eventually paint and with a hard pencil; 2H, which you keep sharp, draw over each and every detail you want transferred.

Since the invention of the camera artists have used them.

If this somehow seems like cheating to you then believe me, all of the best artists have used optics as an aid. As soon as the camera obscura was invented then paintings began to benefit. Compare later works to medieval paintings, look at the perspective aberrations of the medieval painters who didn't have optics to help them, and relax.

Edward Degas' paintings are so expensive today that even prestigious Art Foundations can't afford to

buy them. These were produced with the judicious use of cameras. Degas used to say, that 'creating a painting was like perpetrating a perfect crime'. You just didn't want anyone to know how you had done it.

When you remove the photocopy, your stretched paper or canvas will have on it a ghost outline of the scene that you will soon be turning into a painting.

At this point it doesn't look as good or as lively as an actual pencil drawing but it locates all of the features you wish to reproduce accurately on the surface, in exact proportion and perfect juxtaposition to one another. Should you wish to add something that was not in the general photograph, such as a horse and cart, you can repeat the scribbling process with another photocopy, this time of the horse and cart and place it where ever you wish in the picture you will eventually paint.

Now that you have an accurate scaffold upon which to construct your piece of art, it is time to use your gift to breathe life and beauty into this grey and white thing.

The pencil outline is fairly faint. As soon as you begin to apply even the lightest wash it will appear fainter, so take care. Think what exactly it is that you wish to achieve.

When I begin to paint I look for the lightest colours and hues in the photograph and paint those first. For me the most exciting part of the painting is often the bits I get to leave completely white, unpainted. Experience will help you to pick the right mix of pigments to achieve the correct tone and hue. Just remember that two or three washes of water colour may be placed on

top of one another to great effect. It is however extremely difficult to successfully reduce the colour saturation of a water colour wash once it has been applied.

With oil paints, over painting of areas you wish to modify is always possible. The main thing to consider, at this point, with an oil painting is that once the scaffolding of pencil is painted upon, it becomes invisible, so get your main blocks of colour in carefully and accurately at the beginning.

With water colour, I tend to work from light to dark for a while and then get a bit bored with this tentative approach and have a go at completing one smallish section of the painting, using the full spectrum of lightest and darkest tones. If the result is good, this then encourages me to complete the task.

Physically doing the painting is the hard yards bit for me. Dreaming up exciting end products is what I really enjoy. It is pretty instantaneous, the dreaming bit. The rest takes anything up to two weeks per painting, depending on how confident I feel. Once I am on a roll, then each new painting comes easier and faster but it is difficult to maintain the necessary stream of unhindered concentration when you have a wife, eight children and two dogs. (they are a lot more fun than painting.)

I can't jam a treatise on water colour painting in here, because that's not what the book is about but if you want to make the painting look really good to the eye and ergo, worth plenty of money, there is one thing that you *can* practice to great effect.

Remember that earlier discussion we had about the dunes looking good because they were formed by

natural processes and therefore to the human mind, heart and eye they some how look pure and beautiful?

The same can apply to your paintings. At least in places where you have either been lucky or through practice have picked up a few clues about paint and how it runs and spreads and dries.

If you can allow the paint to make its natural stain on the paper and simultaneously portray what it is you wish it to represent then you will definitely have a thing of beauty.

Study good water colourists. Turner is my absolute favourite. Most of his well known paintings are in oils but he was also a brilliant water colourist. Eugene Delacroix also used water colour for most of his preparatory sketches and again these are masterly.

At one time, when I worked in the conservation department of the Victoria and Albert Museum in London, as a restorer of antiquities, I was privileged to sort through his actual sketch books in preparation for an exhibition of his work at the Royal Academy. They were a study of genius that I will never forget. I would rather own one of Delacroix's smallest water colour sketches than the best Jaguar car on the road.

Notice how great artists allow the paint and the water to do the work. Accomplished water colourists know before hand which part will dry darker than another part and so they can paint a shadow just by allowing the paint to dry darker in certain areas.

Experiment; when a patch of watercolour paint is almost dry, has lost its wet look and just looks damp, drop a blob of clean water into it. See what amazing changes occur.

Artist's quality sap green is a wonderful pigment in this respect. If you paint a tree's foliage shape with sap green, (artists' quality) and blob it with clean drops of water, the result, if you are lucky, will resemble bunches of foliage where originally it was just one flat area of green wash. Not only that, because the capillary action of the water has been doing the work and not the brusque end of a brush the result looks natural and pleasing because it is natural.

You don't have to use this natural technique right across the painting for the work to look accomplished. You just have to select prominent areas to paint in this way and the observer's eye will do the rest.

Many water colourists focus the eye on the centre of their painting by ghosting the periphery and completing detail and tone more and more toward the centre. This is often a very effective technique for making a painting look accomplished.

How to stretch water colour paper.

In case you are not familiar with how to stretch water colour paper here is a brief description.

Stretching water colour paper allows you to access many more surface types than if you stick with water colour board.

Put the sheet of paper into water and immerse it totally for a couple of minutes. Beware of anything that might contaminate the surface and then show up like magic writing when you run a wash of colour over it.

When you lift the soaked paper from the water let

it stick to a vertical clean surface to stop dripping, (not to dry).

When you take it from here to your board, look for the watermark. If the writing is not back to front then you are looking at the best surface to paint on. Lay the wet paper on your board face up and horizontal.

Get some toilet paper and dab-dry the edges of the paper so that the edges are dull to look at whilst the rest of the paper still looks a bit shiny and wet.

Use brown paper adhesive tape to glue the paper to the board. Use a two inch wide tape and have one inch on the paper and one inch on the board and tape around the entire edge.

For a few minutes you will have to occasionally run a finger over the tape on the paper as even when applied wet, the tape absorbs some more water from the damp paper and as the tape expands it tries to come away from the paper or hold a bubble of air. It will stick to the dry board with no fuss.

When you are sure that the tape is securely stuck to board and paper, leave it to dry. Don't be tempted to hurry it in any way.

As the paper dries it will shrink and pull as tight as a drum skin. The force exerted by the paper shrinking is quite powerful, so a thick board is required. If you only have a thin board then you need to shrink two pieces of paper simultaneously one on each side of the board.

When the paper is dry and taut it is ready for your drawing. Be careful not to smudge black pencil onto the surface by accident when transferring your image. Always tape the photocopy, at least along the top so that it doesn't move.

When you put a lovely wash of water colour paint on your paper it will not bulge or cockle as it gets wet again.

Oil painting, though a very different medium, is still more beautiful to behold if the natural forces of the paint are allowed to come into play. I find even the reticulated cracks that appear in paintings that are centuries old, a joy to behold and an enhancement to my enjoyment of the painting as a living thing. Lowry, the English North Country primitive artist, who painted scenes of the mills and the industrial North, that were full of childishly drawn figures, allowed nature to control his paintings in a very distinctive way. You can't purchase it these days, but Lowry used flake white a great deal in his compositions. Flake white is pigmented with lead oxide. It can produce ivory tones that are impossible to create using any other pigment or combination of pigments. Flake white actually becomes more ivory coloured as the years pass. Lowry reckoned that his 'factory in the snow' scenes were not at their best until at least a decade had passed since they had been painted.

Oil paint may be treated somewhat like water colour. Glazes of pigment that have been thinned with oil or turpentine may be applied in layers. However it is when the thicker paint is allowed to drag away from the brush making a broken mark that exactly resembles the light falling on the object depicted, that magic begins to happen. Turner is a master at this type of wildly free painting. Water colour is perhaps the more exacting medium but oils are pure joy for their brilliance and the fact that changes can be successfully made by over

painting.

Anyway, happy painting!

As this is a how to do chapter I can't list all of the tips without becoming tedious.

The following are the highlights:
1. You can become your own master photographer.
2. Take lots of photos
3. Don't tilt cameras unless you want the comic book effect
4. Use photocopies and scribble to transfer images
5. Allow the paint to look like paint even as it represents stuff that isn't paint
6. Stretching watercolour paper is easy and allows you access to differing sizes, weights and textures of paper

5

The game plan

Most business people today were heavily influenced, even as children, by the way their business owning parents, thought, believed and acted. The rest of us went to school and learned to become obedient workers.

The very few artists that existed in cave man times were highly respected individuals. Cave art shows us that it was artists that inspired and taught hunters at a very high, almost spiritual level.

Guess what, this is the level that really good business people have to work on too! You are an artist, right? Soon you are to be an entrepreneurial artist. No one can be taught how to become an artist but anyone can be coached to become businesslike.

We don't have time to go into the history of Palaeolithic cave art in this book but take it from me, the conclusion experts have drawn from the innumerable paintings and decorated artefacts from across the entire world show that the paintings in particular were primitive man's way of visualising the hunt and the victory and of effectively focussing the joint efforts of the hunters on their prey and on their enemies. Artists were revered for that service because visualisation makes things that aren't yet here, come into being. Top athletes these days spend a great deal of their time

visualising the outcome they are striving for.

Your magical ability to focus and visualise can put you streets ahead of modern business gurus in a very important part of the business process. You have to become competent in other areas too, but you are endowed with a strength no business guru can buy unless he pays a visualiser.

The exception proves the rule.

The exception proves the rule of family values being handed down to their children. For example: Cezanne wanted to be a painter. His banking family wanted him to be a banker. If one looks at his early, laboured works, 'The Abduction' or 'The Modern Venus'. That was a very understandable position for them to take. Those paintings were awful!

Frankly, his early work was very ordinary. Because he influenced most subsequent Western artists no one ever says that. Luckily for Cezanne his family funded him and so he had the time to develop his painting and hang out with the most influential writers and painters of his time. His close friends Zola and Pisarro encouraged him and sustained him intellectually and emotionally until he could jettison his attempts to paint paintings that he thought looked like paintings and begin to create original and exceptionally influential works of art.

I have never seen myself as an artist in that sense. That is as an artist who would influence the artistic

work of others. I was, however, good at painting and writing and teaching and influencing others to succeed.

Always align your goals with your passions. My greatest passion is actually writing teaching material.

Artists are the wild cards. They have something amazing that can't actually be taught. They can be taught how to maximize that gift though.

Don't waste your gift.

So you and I are endowed with a gift that is fairly rare amongst the general population. Artists have *vision*, not just some mastery of a technique. Cezanne had a massive vision and finally mastered technique also.

Everyone can learn to write. Most can write words on paper or into a computer. 'Writers', do much more than the technically complex feat of communicating content that has meaning with a bunch of signs on paper. Similarly painters, singers, musicians, sculptors, dancers, actors, et al do something beyond the ordinary when they sing or dance or perform actions that can be performed by any ordinary (ungifted) person.

The difference between my dancing, for example, and that of a professional dancer is noticeable to say the least but, like most people, I can dance.

Artists will discover stuff just by using their imagination. That facility can, if they allow it to, satisfy them into living in a dreamland or a wasteland.

Often the artist is not understood. Is that surprising considering that they are usually doing something new, something beyond the ordinary ken?

So often I hear partially educated Jo Blow, blowing off about modern art. That same Jo accepts without argument that string theory or quantum mechanics must be right because scientists are generally regarded as being very clever and Jo is not really expected to understand anyway.

Success is all about one's self perception. Something has to be ignited for success to occur.

Let me give you an example that will surprise you, but it is true nevertheless.

A colleague of mine, Robert, roughly the same age as me, was a dropout. Lovely guy, terrible self image and of course he spent his entire life ruining his chances of making regular money.

Robert was an extreme case of the intelligent but hopeless victim of life and luck. He would walk through burning coals to help others but as soon as good fortune came his way he seemed to deliberately sabotage his own success. I guess many of us are to some extent like that.

One night, Robert had a dream. He had that same dream on two more consecutive nights. He dreamt that a mentor was showing him how to make money by buying and selling salt, of all things! Not packets of salt, truck loads of it.

To cut the story short, Robert became convinced that his destiny was to become a millionaire through buying and selling salt. He knew nothing about the substance, or about the various industrial markets that he'd have to trade in. Trucks? Robert couldn't even drive a car when he dreamt those dreams!

So strong was this permission offered by the

mentor in the dream, that Robert allowed himself to take the risk of becoming a millionaire! He became one of the few international dealers in salt.

Every year now, he buys and sells hundreds of millions of dollars worth of salt. He still helps people but he doesn't have to walk through fire to do so.

Robert allowed himself, gave himself permission, to succeed as soon as he believed the dream. I had to do that for my work. Bit by bit this book can help you to give yourself the necessary permission and learn the business skills, to make good money from art.

When you first touch the gold, you can move from believing to knowing. Once you know that you are allowed to be a rich artist, nothing can make you poor again unless you let it.

Try not to see success as some bit of luck that you may or may not be blessed by.

A famous Swami once chuckled and answered my questions about success. *"One day succeeds another: that is success"*.

The steps that you climb will be the same steps we all climb and if we keep climbing, the top is the inevitable destination.

Some people choose to go around and around

Take heart

Take heart artistic person. By employing common or garden stuff that anyone can learn, you can begin to use your gift, to earn a living and to grow as an artist at the same time.

It will be exciting and it will be rewarding. When you have begun to succeed at making good money you might stumble upon that which is actually allowing you to get richer. You might begin to see the 3D picture!

After graduating from Leicester Art College and before entering the Royal College of Art, I spent a year travelling in the Middle East, writing poetry and photographing Islamic Art.

During this trip I ran out of money and ended up running a hotel in Cyprus for about six months. At first, the hotel made a loss. Then some Jewish New York Beat-nicks stopped on their way to India.

Being Jewish they were very good at business and believed in their right to riches even though they were, temporarily, behaving like drop outs. The father of one of them, Joel, was purportedly the 'Potato Salad King' of New York.

These lovely people showed me how to turn that particular business around. I got to know at first hand that even an artist can be taught to succeed at making money. At the time however I did not receive the blessing of 'the right to riches'.

Obadiah's Gasworks

My first ever Art business venture began when I was studying at the Royal College of Art, London. At the time I failed to recognise that it actually was a business. I just began having fun and making money. I had a good friend, Hugh. It was he who really inspired me to get into the business.

Actually he gave me the metaphorical kick in the pants I needed! He taught me that plenty of money is always out there for the plucking. He showed me that we had a right to riches and that he knew we did and I didn't.

Hugh liked to travel. Each summer break he would head off to India or Africa or somewhere exotic, but not as a back packer. No, no, Hugh was a bit of a wag. He always carried one cricket pad and his favourite bat strapped to his luggage, when he set off on these pseudo Victorian adventures.

Hugh reminded me of some character from an Oscar Wilde play, careless and fancy free.

Returning from a trip to India, Hugh brought with him a 1927 Rolls Royce hearse that had been hand built for some minor rajah! Hugh had done a deal with the Rajah's eldest son and swapped his three year old, E Type jag for the Roller!

My eccentric and rich friend had bought one of the very first E Type Jags to come off the assembly line and had driven it from London to India at the start of the summer break.

At the end of his holiday he drove home in the Rolls Royce hearse he had acquired as a swap! Even when he got it back to London, the Rolls still had less than ten thousand miles on the clock!

It had cut glass side and rear windows, purple crystal corner lanterns, a filigreed silver and teak roof rack and genuine tiger skin upholstery!

After parading it around the watering holes of Chelsea, the Portobello Road markets and the houses of admiring colleagues in Belgravia, my friend part

exchanged this wondrous creation for a white Steinway Grand piano. The instrument had at one time been owned by the D'Oyle Carte Company, producers of the many Gilbert and Sullivan comic operas. Hugh made enough cash to buy the piano, an MG midget and to see him right for another two hedonistic years in Art College!

Doesn't that type of confidence and freedom with money make you sick? It made me sick but it also forced me to see what was possible for those who realised that we have a right to riches.

Jealousy overwhelmed me because, at the time, I felt spiritually unable to emulate this entrepreneurial triumph. I felt unable to shake off the "work for a living chains' that strangled my courage and deferred my every moment of determination.

Spurred and inspired by my friend's shocking good fortune I launched what I later realised was actually my first business: 'Obadiah's Gasworks'. I also, angrily made myself a lute. *'Let's face it'*, I comforted myself, *'Anyone can get a second hand piano!'*

I had been at the Royal College for about a year when I was invited to run the senior common room disco. It was the sizzling sixties, a time of reckless rule breaking. I was a student in the department of 'Light Transmission and Projection!'

Formerly and since the time when Charles Darwin had been principal of the Royal College, this department had simply been called 'The Stained Glass Department'.

As a painter and inventor I just loved the atmosphere of wildly experimental work that was going

on there. For the previous three years at Leicester Art College I had been producing light and sound constructions and environments under the tutelage of Harry Thubron. I had won a scholarship to study for a term at the Musée Illuminaire in Paris so when I got back to London I was raring to go with new light and sound creations just swamping my imagination.

"Could you find the time to run the College Disco, Roy?"

Let me put you in the picture. For a light and sound experimental artist I had, on receipt of this invitation, fallen into the equivalent of Ali Baba's Cave.

The college disco was very well funded. It was within spitting distance of the Imperial College of Science where a friend of mine had access to a new invention that was still awaiting a use; the laser! She also had access to lots of other wild equipment! We obtained Van De Graff generators, Tesla coils and ultra violet lamps that could take your skin off.

I know, fools rush in and I did. To add to this good fortune, the college of Mining Engineers was just the other side of the Albert Hall from us. The students there could build anything man could conceive of and with very little encouragement, they frequently did.

Flower power was suddenly going electric in Kensington Gore, London SW7 and 'Obadiah's Gasworks' was born in a flash!

Why the name Obadiah's Gasworks? You ask. It was the product of mad times. Apocalyptic sounding, a bit anti-establishment and the 'Electric Cinema', in Notting Hill had already used the other prime word for light producing energy.

Obadiah's Gasworks developed light shows to complement the work of pop groups. We hired ourselves out as an accessory. Some of our equipment was linked directly to the sound of the band. Our light show was synchronised in hue, tone, volume, and light patterns, exactly to the music.

We hired ourselves to the Royal College Common Room and to any pop group that could afford us. Our competition, still happily excited by coloured oil and water projectors and bicycle wheels with cardboard quadrants spinning in front of spotlights, didn't get a look in.

Easy come, easy go was the order of the day. Money actually went out more consistently than it came in. It used to come in, in torrents and run out like rivers. We got rid of it because we didn't feel we had a right to such riches. We wouldn't have agreed with that assessment at the time but I have since learned that knowing you have a right to riches is the most important factor in getting to be and staying wealthy.

It was the sort of experience that couldn't be attained in any other way, I console myself. It has taken me years to figure out all that went wrong in those heady days. The main thing that was wrong for me was my vision of myself, still as a mere artist and still poor.

The 'almost' highlight for Obadiah's gasworks was to be a charity do at the Royal Albert Hall featuring the Stones and the Beatles on the same stage!

Rank Strand and Thorn electrics had promised me all the equipment I would need to build a giant, interactive screen of pygmy bulbs on a turntable that revolved in the middle of the circular auditorium.

Ten days before the gig, the Albert Hall paid a massive penalty and bugged out of the contract. Even if the big one had happened however I would still have lost it all because I still remained unaware of my right to riches.

OK, its time to get a grip on 'making some money from Art and keeping it'.

Taking Control of your future.

Taking control is exciting and empowering. It must become a habit you live by.

The only person who ever fails is the person who actually tries. If you decide never to try again then you won't ever fail again but remember that a rut is really a grave with both ends open.

That first excitement when someone rewards you with lots of money in exchange for your effort is priceless. You've touched a vein of gold. This is not by chance. Just like hand writing and counting; everyone can learn to find gold. But will they?

Why did you learn to write? Why did you learn to count?

You did it because it was the right thing to do. Everybody does it and your school taught you to do it.

No school is going to teach you to be clever with money or business. No sir! That is not what schools were designed for. No ordinary school will even guess at never mind teach that we all have a right to riches.

The British East India Company ruled a continent and continually extended the British Empire. That

International Conglomerate actually designed the education system we all know, love and admire. They designed it, not to satisfy some philanthropic urge to help the unwashed masses. The British East India Company designed the British Educational System that so much of the world has emulated so that they would have a regular supply of clerks and managers and executives to work for them in their burgeoning, world wide, business-empire.

Independence of spirit, entrepreneurial skills and financial management were never encouraged nor taught at state schools and they still aren't.

No where, in any but the poshest of public schools, was an appreciation for the value, the right to, and the intelligent use of, money actually taught!

The three R's are indeed useful, but all that lining up and sitting still and silent and the reward and punishment ethos, produced clerks who were obedient, punctual, reasonably skilled and followed orders. The R that you and I need burned into our souls is the r that stands for right.

Only someone working as a shipping clerk in the office of a global business could possibly make good use of the catalogue of irrelevant facts that clogged my brain by the time I left grammar school. I will always know that Lima is the capital of Peru! I've never been there though.

So get yourself started.

This is not a school essay.

In less than 20 words describe your money making idea or just the thing you really want to do. Keep it simple but totally honest. Don't write what looks good or what you feel the world wants you to want.

Having described it, give it a name that absolutely defines it. This might take you some considerable time.

Here's an example: "I am going to design and market retro, photo-silk-screen reproductions of pre-Raphaelite paintings that are excitingly erotic, very detailed and highly priced. I will call my business Blueprints."

I just made that up as an example of the definition of a small business idea and a business name. It doesn't matter if the idea is to make something odd: 'Prints and calendars of the Simpson Desert in the Snow', done with silkscreen, airbrush, glue and white flock. It is just important to figure out what you really want to do, however mad or however ordinary, own it and then write it down as succinctly as you can. Then name it and voila! It exists!

1) Figure out what you want to do. Not what you think you *should* want to do.

2) Describe it very precisely. Make it real. Bring it into existence so that you do believe it.

3) Find a name for it that is quirky but encompassing. (Quirky gets attention).

4) Challenge yourself as to whether you believe you have a right to do it or not.

Ideas need to be turned into money making systems if they are going to make you a living or better still, make you rich.

The trick is to turn any idea into a system for

printing money. No easy task that, but it definitely needs a vision and some permission first. You have to feel totally right about it.

From this chapter we have discovered that:
1. Visualisation has given man control over his world since mankind has existed
2. Always align your goals with your passions
3. Don't waste your gift
4. Start to figure out how you can give yourself convincing permission to succeed.
5. Permission always has to be obtained. By whom that permission is granted does not concern the sleeping giant within you. Start giving yourself permission, the right to riches
6. Write down and regularly review and if necessary revise, precisely what it is you wish to bring to fruition.

6

My first $10,000 painting

In 1985 after my first marriage of 17 years went to pieces, I went to pieces too. I lost a very good business, I felt guilty, I lost my house and family, I was a wreck. I lived in a wooden shack that my sister's family had as a summer thing and I had little money and no job.

On top of that I became too ill to actually do much work even if I could have found some.

I remember lying ill in bed listening to the rain hammering on the roof and dripping into a variety of containers placed strategically through out the shack. I didn't want to go on the dole but I desperately needed money.

I had one skill that I had never, ever thought of as a realistic income generator. I was reasonably good at painting.

My savings were rapidly dwindling. A box of good watercolour paints was a very expensive investment for an out of work, sick business man.

Could I make money from selling paintings? I had sold one or two paintings to friends in the distant past. I was just a kid then, they probably bought them to be kind.

I agonised for days, scared to make the decision to try and do something.

I was a whipped wimp.

You are not going to believe what happened next.

As I was trudging, head down, along a busy shopping street in town, I saw a plain white cardboard box lying on the pavement. The crowd of busy shoppers was just walking straight past totally ignoring it.

I bent and picked it up. It felt intriguingly heavy for its size. It was a clean, narrow plain white cardboard box about ten inches long. It may have slipped out of a coloured paper sleeve and dropped to the ground. I don't know.

I ripped open one end and out slid a brand new, shiny, black, metal, top of the range, box of Windsor & Newton, Artist's water colours! I was astonished. I couldn't have been more surprised if it had been a bar of gold. I looked around to try and see who might have dropped this treasure but no one even looked at me as I held this beautiful, expensive, box full of bright new paints. It had a fold-out palette and two brushes.

Can you imagine my astonishment? Can you believe the incredible good fortune and total coincidence? That a needy businessman\water colour artist trying to make up his mind whether to risk all his remaining money and purchase the means to make a painting, should find this incredible gift lying on a busy pavement. (I still use that same box).

I spent a precious thirty shillings, (two dollars) on a fine piece of heavy, water colour paper and made my way home.

My sister's holiday shack was near a dramatically attractive bay called, 'Three Cliffs'. I carefully cut the large sheet of water colour paper into four equal pieces. With a screwdriver I removed a cupboard door from its

hinges and stretched a piece of the paper onto it. I took my 'board' and my precious paints to three cliffs and painted.

As soon as the painting was dry I cut it neatly from the board and took it to the souvenir shop near the bay road and sold it for a princely ten quid! ($20), I was rapt!

You may be surprised that I was really pleased with a mere ten quid. What I was seeing was not ten quid I was seeing that I had taken a piece of paper worth less than eight shillings, used some water colour on it and then sold the same for $20. I had achieved a profit margin of 300% at my first attempt! Do not despise small beginnings.

Three Cliff's proved to be very saleable as subject matter for paintings. I made forty quid ($80) in a couple of days and realised I was going to survive. I was making cash and no one could touch it! Not my ex's solicitors, nor the tax man. Somehow finding the box of paints had helped me give myself permission to make a living again.

Somewhere in my boxes of belongings I remembered I had a 35mm camera. I fished it out, bought a film and took twenty four photos of my latest three cliffs painting.

When the prints came back I took them to the gift shop near the bay, but the prints were glossy and very obviously photos and no one was interested.

This was my first knock back, but by now I had recovered enough guts to take it in my stride.

I bought some brown fountain pen ink. Filled my pen and signed and numbered the twenty four glossy photos and then took them to a laminating place and

had them backed with thin card and laminated in a matt plastic sleeve.

The thousands of tiny see through beads on the surface of the matt film made the photos slightly fuzzy, not so sharp, and this actually enhanced the look of them as water colour prints. I took these to the souvenir shops and sold them all!

I had made my first $120, from one painting and I still owned the original painting. Wow! I was back in business!

My sister's shack was on the edge of a peninsular; The Gower Peninsula. This was acclaimed as an area of great natural beauty and it was a total tourist Mecca.

There were lots of bays and hotels and pretty, dramatic places and souvenir shops sprinkled all around the coastline of this twenty mile long peninsula.

I bought myself a posh push bike with panniers, filled those panniers with cardboard backed, plastic coated, limited edition, signed and numbered prints. Not just of Three Cliffs of course but of every little gem I could find and paint.

Each weekend I would cycle around the Gower Peninsula re-stocking lots of little souvenir shops with my cheap prints. I was earning about six hundred dollars a week, net and loving it.

What about this ten thousand dollar painting you mentioned?

I was just coming to that.

Now that starvation was no longer an imminent threat I had begun to really enjoy the feeling of being a trouble free artist. This was a great change from having been a stressed out business man who'd had a healthy

income but no time to enjoy it.

I made myself an easel and began to paint less commercial, but personally, more interesting scenes.

I began to sell originals through galleries for about $600 each but the galleries always took thirty percent of the asking price. That really bugged me.

Then I got the $10,000 painting idea!

It worked and I began to make money as an entrepreneurial artist, hand over fist.

Paint and grow rich!

Swansea is a small town in South Wales. It is not known for its love of the arts. The town is merely a quiet backwater in post industrial Britain.

In the 1980's, which is when I first began to apply the art of Business to the business of Art, no one would have ever picked this sleepy little town as a suitable target for an art marketing adventure.

I say this because you may live in Wigan or Toledo or Wagga Wagga and thus be tempted to conclude that my methods couldn't work for you there, in your own unpromising location.

They could.

The ideas I present can guarantee that you can make good money from artistic endeavour anywhere on earth where people choose to live and actually earn living wages.

I love water colour and so I was at my happiest working in that medium.

As I say, my original work was now being bought

for around $600 per painting. My business 'friends' were back and they congratulated me but I was somewhat embarrassed by their praise. Each of these larger paintings had taken me a week to paint.

I had been used to earning good money as CEO of my small company.

As a water colourist, I was really only earning around $10 per hour when every thing was taken into consideration. I felt that a check-out-chick could have done better.

I put my business man's hat back on and tried to figure out how to multiply the return from a painting by at least ten times.

I came up with some rules to follow.

Lots of ineffective people unknowingly spend much of their creative energy, constantly thinking about and reinventing the wheel that they have already invented.

When you realise that you have some idea of what to do, write it down as a series of things to be done.

This may sound boring but creating a to do list won't take long and it will allow you to concentrate on doing and stop you from wasting precious creative energy rethinking what to do and when and how to do it, all of the time.

A list is not bondage it is freedom. It gives you the freedom to do work, without further speculation.

You really have to get this habit of making a list of steps to take and own it.

One of the iron clad rules of every market says: that you find out what people want and then offer it to them. You don't just make what you want and then try to find

someone to buy it.

This important principle can make life difficult for an artist who simply wants to do their own thing. I love boats and reflections and buildings to be in my paintings. Not necessarily all at the same time but these are the sorts of things that I delight in painting.

What I did for that first $10,000 painting was; I searched for a scene in which I could delight, that would also be a scene which would find a ready market of people who might want to purchase such a painting.

Early on you have to take the audience into consideration. Once you are an established painter then the intrinsic value of your work will naturally increase because some people will start to collect just about anything you paint.

Another iron clad rule in marketing is: make sure that everyone involved gets good value for their money.

You are building a reputation. Your paintings will increase in value because people agree that they are valuable. Their agreement is the only yardstick for the value of your paintings. So look after all of your prospects. Make them agree that you are a good person and a good artist.

- Find out what people want
- Get people excited about your work and make them glad to be somehow involved in it. Collectors love to feel involved.
- Don't be shy! Trumpet your offering to the world.
- Make sure that you create a win, win situation.
- Assess what the market will stand, price wise. Do this accurately.
- Recognise that what you are doing is much more

than simply painting pictures for money.
- Look hard. See your activity in the broadest way you can and define precisely what business you are in.

There are a few points left to make but let's deal with this first few right away and explore how my $10,000 painting satisfies each point.

Find out what people want.

I decided to paint a large and colourful watercolour of the new Swansea Marina. That marina had lots of beautiful and expensive yachts, a red, Trinity House light vessel (a sort of floating lighthouse) and groups of ornamentally vogue dwellings of the upwardly mobile, all framing a glassy sea of sumptuous reflections.

Slap bang in the middle of the background, standing majestically on a quayside and just to the left of the bright red, Trinity House, light vessel was the poshest restaurant and trend-setting bar in Swansea Town.

The scene was perfect for a water colour painting. This was also a very, in-vogue , part of town. I knew that people would like a painting of it because it was the sort of place that people regularly strolled around and visited. It was just a really good looking and pleasant part of town.

The painting came out easily and beautifully, I love reflections, and the painting was impressively large too, on purpose. I got it framed in the most expensive moulding suitable and had one thousand, 9" by 5" prints of a detail of the original reproduced on heavy art paper.

Seeing even a small section of one of my own paintings reproduced that many times was like a tonic. Don't ever underestimate the power that comes when you actually do something for the first time or see something or better still, both.

I had invested $350 in this print run. In those days that was a fair whack of money. I am dwelling on this print business because just seeing those prints got me really stoked.

At least two things happened.

I became very excited and proud of my work because I was seeing so many images of my painting spread about the place.

I had spent money and I was damned if I was going to ever bin these prints. The cost increased my motivation. I had paid $350 for prints. $350 + excitement = action. Action is the only pathway to success.

I can still feel the weight and smell the aroma of the 'hot off the press, one thousand prints', as I write about them decades later. Don't underestimate the power of this level of self-affirmation. It works like magic!

The next job was more difficult and tedious for me. I had to sign and number the prints.

Accurately reproducing one's signature five times is hard, a thousand times is very hard. Soon however I threw caution to the winds and just signed and signed.

When I had finished signing and numbering the prints I had a limited edition of prints, ready to sell. If that had been the total idea I would probably still be trying to sell the last of them today, but there was more!

Get people involved and excited about your work.

The next entrepreneurial twist was the real kicker. I took my sumptuously framed, large, original painting to the restaurant on the marina quay.

This was of course, the restaurant that was featured almost at the centre of the painting and the restaurant was also at the centre of my limited edition prints.

I took along a handful of those, wonderful little prints.

I explained my business of Art idea, to the owners of the restaurant and they were delighted. They hung my painting very prominently in their posh dining room. This was the very eating place that was frequented by the top segment of my target market.

The next thing I did was to ring the editor of the local newspaper. Although I had previously sold him a couple of paintings I would have rung him anyway. The fact that he owned a couple of my paintings just made the thing more fun.

Don't be shy, trumpet your work to the world

When he answered the phone I introduced myself and told him that my latest painting was a large and beautifully framed painting of the marina and that, wait for it, I was selling it for a mere four pounds! (Approximately $10)

Initially there was silence on the other end of the phone. This guy had bought two paintings from me and neither had cost him less than $450! Where was the trick? Was I trying to con him?

I assured him, when he recovered his voice, that someone would be lucky enough to purchase this

original painting of the marina, in its frame for a mere $10.

I then explained to him my idea.

Each limited edition print would be sold for $10. Within three to four months a draw would be held in the restaurant and the purchaser of the print whose number was drawn would get the original, in its frame, for free!

Please note that any editor of a small local newspaper can be made excited enough to publish a short article about such an unusual marketing ploy. The fact that Mr Savage, the editor, already owned two of my paintings only increased his interest.

Once a critical amount of committed and clever activity has actually taken place the snowball effect begins to kick in!

I got a phone call from a friend of the editor's. This friend was the local business guru and hosted a daily, business breakfast half hour, on 'Swansea Sound', the local radio station. He rang to congratulate me on my creative marketing idea and asked for details of the venue and the draw etc.

During this conversation I took another risk. I asked him if he would consider being the master of ceremonies on the night of the draw, at the posh restaurant.

He agreed! Provided the draw was held in no more than six weeks time. (Deadlines are very motivating).

Now who is a whipped wimp? Action changes everything.

The very next day the newspaper ran the story and included a photograph of myself and the business guru

holding the painting between us.

The story was also featured on Swansea Sound that week and several times before the night of the draw.

That particular snowball was just the icing, if you'll excuse the pun.

The idea would have worked even if the editor hadn't known me. I would just have had to work a little harder to get the story broadcast as well as printed. These days community TV networks make this strategy much easier to implement.

The limited edition prints sold at florist shops, art and framing galleries, curio and tourist shops near the marina and of course, at the posh restaurant and my beauty spot, gift shops all around the Gower peninsula.

We didn't manage to sell all of the prints by the time the six week deadline that the business guru persuaded me to set, had arrived. We had, however, sold over nine hundred and sold another twenty eight on the night of the draw. In total just short of 950 prints were sold before the draw (So we were definitely charging what the market would stand for the prints, probably a little less but there was the time constraint of six weeks to consider.)

On the night of the draw the restaurant hired two hundred extra chairs and arranged them alfresco on the quay outside the arcade of open French windows that ran across the front of the main dining room.

This was a gala summer night in the Swansea marina.

The business guru handled the microphone with professional skill and whit. The tills were tinkling the laughter was joyful and the wine flowed like water.

The framer who had put the expensive moulding around the large, original watercolour had also framed ten of the limited edition prints. These were given away as consolation prizes. He donated the frames free of charge for the privilege of advertising his framing service on the original painting and on the table of small, framed prints and with a gold foil sticker on the back of each limited edition print\ raffle ticket that had been sold.

That evening was a ball and the joyful new owner of the original painting was totally chuffed. Luckily for me the business guru had the presence of mind to get the winner's name address and telephone number. People weren't touchy about such things in those days.

I later borrowed the original back and had a few hundred full sized prints made of it.

So let's have a look at what happened.

Create a win, win situation.

This idea had created sixteen major winners. Always a good thing, create winners and they love you.

Obviously the main winner won the original painting. Then there were ten consolation winners of frames that fit their limited edition prints. The framer won, the restaurant owners won, the paper won and the guru won and of course I won.

The 950 purchasers of prints also won because their limited edition, $10 prints were now definitely worth more than when they had been purchased.

In fact the remaining thirty odd, limited edition prints sold through galleries for an average of $55 each

during the following year.

The few marina galleries that had any of my original paintings on display sold them that week.

The restaurant changed their menus and cards to include a detail of the original painting and paid me for the privilege of using this piece of graphic art.

I had a good place to hang any further works for free, right in front of my target market.

Within eighteen months, by pursuing that and similar, better strategies I had bought a 300 hundred year old house in the prestigious Gower Peninsula and doubled the number of its rooms.

I was also driving a new car instead of riding a bike.

A band wagon was rolling and you will have to go to my website to get the rest of that story.

That first really entrepreneurial idea was effective in 1985 and still is effective. Let me tell you though, it was primitive compared with the art of Business in the business of Art I'm enjoying doing right now, twenty years later!

What is the take home, show bag of ideas we have here?

You have to be bold, know what you want to do and do it. I can't emphasise enough that most people, artists or not, don't really know what they want to do, so they mill about in life going nowhere. Perhaps they do know what they want to do, but don't really believe they have a chance of doing it. So they never really try. That way they don't ever suffer a defeat. The person who has determined precisely what they want to do, can definitely do it. Nike spent a fortune for the slogan:

"Just do it", take their advice cos it works.

You like to paint abstract impressionist works. Fine, there is nothing there that can't make you a fortune. Take your public with you though.

When I was running Obadiah's Gasworks to pay for my time as a student at the Royal College of Art, we were contracted at one time to do psychedelic lights for a rising star called Jimi Hendrix.

He was performing at an aircraft hanger of an auditorium in Leicester, England. When Hendrix first serenaded the audience with his wildly screaming guitar and overloaded amplifier he got boos from the late 60's audience!

Instead of taking the hump at this, Jimi bowed graciously and began to play classical guitar on his red electric.

Gradually he brought the audience through the evolutionary journey he had followed and by the end of the night his guitar was again screaming into an overloaded amp and the audience loved him. Abstract impressionism doesn't have to cut you off from the money.

The motivation to win the game comes either from inspiration or desperation. A truck certainly came down my rut, I didn't want it to and I am still sorry that I was foolish enough for allowing a disaster of that magnitude to almost take me out, but it motivated me alright.

I think you must agree with me that inspiration is the better motivator given the choice. This book and my website will give you that choice.

I can't prove it, but when a man or woman decides to do something or die, the universe allows it to happen

and sometimes gifts that person.

I still believe that that paint box was a gift from the angels looking after me. I know that I hadn't decided to do something particular but I also know that I had not just given up. I was definitely in the market for an idea to follow. Had I not been, I might have merely sold that box of paints for fifty quid or so, or like the crowds of shoppers also on that street, not even stooped to pick it up.

Use everything that is put your way and use it while it is still warm. I can still remember wondering, as I dipped my wet brush for the first time into that pristine box of paints, wondering if I could still paint.

Take heart and just do it.

If it works keep doing it for a while, you will still be learning. I did about fifteen paintings of three cliffs bay and the last one was the best one. (Compared with the 1000 views of Mount Fiji, painted by the famous genius Hokusai, my 15 paintings of Three Cliffs, wasn't even warming up.)

If a set back occurs don't let it stop you. When people turned up their noses at my photos of my painting of three cliffs they were quite rude. Instead of being jolted back a square and just selling originals again I started to ask shop keepers what they didn't like about them. This is your life, so why not be bold about living it. I found out that the glossy prints were perceived as just photographs. I thought out a way of making those photos look like what they weren't. I was only selling them for a $10, so concern over their archival durability didn't even enter the equation.

Even as I write this I can remember the hunter gatherer thrill of loading my bike's panniers with prints, riding off around my hunting ground and returning, tired and happy, with pockets full of cash.

Swapping a print for a meal at a café, cum gift shop was also a very pleasant buzz for me.

Apart from the trauma of losing my kids, some aspects of that summer were the happiest of my life. I met my current, lovely, accountant wife then and we have now been very happily married for over twenty years.

Don't sell your work through a gallery, unless you own the gallery or have a stake in it. See my website to find out how to become the owner of several galleries.

Be happy to pay the universe back for its gift of life. Be generous and care for others. Don't, however, let yourself off the hook by giving everything away and martyring yourself. It takes guts to make money and keep it and to let it make more money. Giving it all away is so easy any fool can do it.

Success breeds success, failure stops activity. Give yourself small goals at first and allow success to excite you towards bigger goals.

Find an inspirational book that suits you and read it and read it and then, do what it says.

There are tons of excellent books out there all saying very similar things. Some people keep buying inspiring books hoping that one day they will know so much about getting rich that they will just get rich. That ain't going to happen, baby. Get one good book and live it out. That will work!

You can paint and grow rich anywhere. If you are

small you need to be somewhere small to succeed easily. When you are big then the metropolis might be a better place for you to make big bucks, fast.

I was earning ten dollars an hour, less than a check out chick, but I was doing what I wanted and had control of my life again. Don't despise small beginnings.

Give people what they want. They will love you for it and better still they will pay you for it. Let's face it; people have a perfect right to want stuff that you think is not quite the tops.

Remember Jimi. Hendrix?

Thank people for being interested in your work. It gets them involved. People love to be involved, figure out how best to involve people in your success.

Always give good value for good money. Prints cost little, so don't charge too much for them. Every print you sell makes everything else you do more valuable.

Prints are not simply products they are also promotional devices of the top order. The more prints you sell, limited or not, the higher the intrinsic value of the original painting climbs. The greater the number of people that agree that your work is valued the more valued it is. Each piece of work and each print sold will become a stepping stone to greater things.

Don't be shy. Don't be arrogant either but definitely don't be shy. Tell everybody how good you are and how much you love what you are doing. Excitement is contagious, infect your public but more importantly infect yourself. Don't ever pretend to be excited, it doesn't work!

What business are you in? Defining that is not easy

but it is critical. There are two Gyms near my home. One is the local squash club, one a health and fitness centre. Squash is played at both venues and in fact they are similar in all aspects but the name. Guess which one prospers the best; the one that recognises that it is in the health business.

The squash club is dowdy and poor looking. The health and fitness centre is bright and prosperous.

Keep, your snowball moving. Watch the ground ahead carefully, trundle down the slopes, watch out for a plateau because trying to re-start a large snowball and get it back onto the down hill from a flat, is very hard, near impossible work.

Get stuff published in the local rag. Small towns have small newspapers. Small newspapers have small staffs. Give them ready made copy that will fit without any alteration and they can't resist it.

You will be doing their job of filling the paper with tits bits for them. Get published and grow. Do the hard yards to make sure the copy is excellent and so are the photos.

Getting published, gets easier as you go and as you grow.

You become more interesting, people value what you do and a chain reaction begins.

If you are any good at writing try to get a small column on art going in the local rag. Offer to do it for free; it will be an excellent self promotion.

Add what ever you can to your personal brand. Most people will be trying to make some money out of the small things like writing a column.

You will have your mind on the bigger picture and

can afford to write for free because it adds value to your brand.

Small newspapers and magazines, love free copy if it is good and needs no work on their part.

Watch what you say about yourself even in private. Never use negative words towards yourself even when no one else is about. Always make very positive self-affirmations. Make this self affirmation a good habit that you cultivate. Talk yourself up and celebrate every small success. Don't kid yourself but just become aware of exactly how valuable you really are.

Just out of interest how much would you sell your right eye for? Would you sell it for a million dollars? Remember, take an inventory of your physical value and then having surprised yourself at your intrinsic physical value, think about your mind and then your spirit, your creativity. You are worth squillions, just don't sit on it till it rots!

So how much money did that one big painting actually make?

I paid $6 for the water colour paper and $350 for the small prints. I also paid $350 for the ornate frame but later got that refunded by the framer once he saw that the draw would actually sell in excess of 500 prints.

Between everything then I actually risked less than $400.

I sold 957 prints @ $10ea. = $9570.

I sold the balance of 40 prints for $1200 less 30% = $800.

So I got my $10,000 and I also got $500 for the restaurant cards, note paper and menu graphics, featuring a portion of my painting.

Taking the risk of going to see people and ringing people was the hardest part of the exercise and that got easier once the ball was rolling.

Success bred success, it really did. When I told the restaurant owner my idea he was very complimentary about it. He loved it.

The next step was so easy and my face was already burning with the excitement of getting something happening. When I rang the editor of the South Wales Evening Post, I could hardly contain my excitement.

From there the thing took on its own momentum.

Is $10,000 for a painting too big a first bite for you?

If so try the $1500 per painting. That is what this next chapter is about.

This has been quite a chapter so what is there to take home?

1. Inspiration and desperation can both goad a person into successful activity
2. When you are doing what you should be doing it is enjoyable
3. The $10,000 painting idea works where ever people earn money and reside.
4. Create to do lists before you begin the day, it will save you thinking when you should be doing.
5. Give people what they want until they want everything you have to give them
6. Get people involved in what you are doing
7. Don't be shy
8. The local media is always thirsty for local news. My website has a help section regarding news story production

9. Action changes everything
10. Engage the hunter gatherer instinct and watch your prints fly. Offer a raffle ticket that is also a signed and numbered limited edition print at a very reasonable price
11. Create plenty of winners
12. Do the James Hendrix thing and take your public with you
13. Be generous but without martyring yourself
14. Grab every idea in this book and squeeze the life out of it
15. Remember that every print of your work in existence is a wonderful promotional device
16. Instruct the inner giant about your right to riches and reinforce this practice by never saying an ill word about yourself
17. You are already worth millions, wake up and act like it

7

The Local Bowling Club

Let's just say you want to sell prints of four paintings and make a total net profit of $6,000. This is $1500 per painting and you will still be retaining the originals.

Remember, what we are building here is a career and a reputation and at the same time increasing the intrinsic value of your original work.

How can you paint four paintings, sell prints from them quickly and easily, so that you make $6000 profit in a matter of weeks without losing the originals? Very simply!

Clubs are everywhere!

Perth, Western Australia, is actually a city but compared to any European city it is just a big country town. Being in Australia however, means that Perth's denizens have a great love of sport. There are actually over 850 sporting and social clubs listed in the telephone yellow pages for Perth! Perth, Western Australia has a population of 1 million.

So what?

Sporting clubs and social clubs regularly have to raise funds through various activities.

This can become an inexhaustible and increasingly profitable market for your work if you begin to use a

technique that I have honed to perfection.

The larger the club membership the more lucrative your relationship with that club can become.

Larger clubs, however, are much harder to deal with than smaller clubs. A million dollars is a lot of money to artists like you and me but to a premier football club it is insignificant; just loose change.

So as a beginner start with a small club. Confidence plus a track record, will then allow you to access much more lucrative work further down the track.

Perhaps the least prestigious type of club amongst the sporting community is the local bowling club.

There are over 60 of these in Perth alone and the average number of members per club is around the 250 mark.

Full memberships generally cost an average of around $200 per year.

From membership fees alone then the average club makes only about $40,000 - $50,000 per annum.

The costs such a club incurs include: wages for full time green keepers, caretakers, bar staff, rates, maintenance etc, etc.

Do they need to find additional funds each year?

Absolutely they do!

I puzzled for a couple of years over the relatively soft target of the local bowling clubs.

The problem with bowling clubs is not that they don't need to generate additional funding, they do.

The problem is that unlike our $10,000 painting we are unable to sell a thousand cheap prints when the total membership of the club is only 250.

No more than half of the members will buy

anyway.

So this is what you can do.

Pick a smallish club. The clubhouse and greens must look good if only for your own enjoyment as an artist.

How do you help them to get $1500 extra into their fund coffers?

You give them $1500 from prints of your paintings and they let you walk away with a $6000 net profit for yourself plus a whole new batch of original paintings?

On a day when the greens are fully occupied, take photographs and sketches from every conceivable angle. Do some rough colour studies. Be professional and be seen to be doing the *business of Art*. Someone is bound to ask you what you are up to. You are a local artist, you love the look of the Bowling Club and you fancy doing a series of paintings of the club. Just tell them that and no more.

Produce four water colour paintings of the main green and include the building. Make the main paintings, views from each of the four corners of the green. Leave space on your stretched paper or on your canvas for smaller, supplementary vignettes of members or of cute corners of the club. Include lots of little details in your sketching.

If you have to, get the printing firm to cut and paste and produce four prints that between them illustrate the bowling club to the fullest with a main painting on each print plus a selection of vignettes surrounding it.

It will be much more profitable, however, if you do the cutting and pasting yourself, physically, as you work. Get used to making interesting groups of sketches

and studies around a main theme and all on the same piece of stretched watercolour paper.

If you can't place the painted areas successfully whilst you are painting then cut them out and remount them using magic tape. It will cover the joins and not show up in the final amalgamated print.

When you are collecting your bijou shots for the paintings try to discover little intimate areas that are likely to be memorable to club members. Seating places, groups of spectators, the bar and of course bowling characters in action.

Having produced the framed, photocopied prints to your satisfaction, contact the club secretary.

Don't go wasting your time with people who can't say yay or nay.

When you meet with the secretary say that that whilst you were busy with the sketches and the paintings the thought struck you that using them, you could easily raise $1500 for the club funds.

Cut your coat according to what you are good at painting and focus on those detail and scenes where you feel most competent.

Let's get back to the bowling club.

The one I am currently painting is small, (Less than 250 members) but it has a pleasant brick and tile club house, excellent greens and it looks good from each of the four cardinal points of the compass.

Look carefully at the Scotch College poster on my website and consider the design of your poster\prints well.

For a start there should be four final prints. None of them should be large. Design them so that they make a

nice set of prints when framed.

Within the four prints any conceivable feature of the club can be recorded. Consider the shape of the prints. Do they make an attractive set?

Sets are what you should be selling rather than individual prints. So make them look attractive as a group. Consider not just the composition of each but the shape of the frame, how they will be best hung as a group.

Try to restrict the palette so that they have a group feel. You don't want an *odd man out* feeling to any of them. The shape of the print should be interesting but not dramatic.

Remember the customer is probably fairly conservative in taste. I suggest each print should be either a letterbox shape or absolutely square.

If you have nothing to show the club, up front, such as a similar set of prints you have previously produced, then do this.

Paint the four paintings on spec. Do them in the same the way that I went about selling my first $10,000 painting.

Get them framed before you show them to the committee. Coloured photo copy ensembles for prints will suffice if they are well framed.

Don't pay for the frames, read on and discover how to get them for free.

If you already have something in print like the Scotch College print to take with you then use that to test the water.

Talk to the committee about your idea for raising funds for the club and point out that not only will your

idea result in $1500 hard cash in their coffers they will also benefit from the promotional side-effects four hundred such pictures of their club can generate in the local community.

Bowling clubs are always looking to increase membership or at least to counter the natural attrition. Their membership will be partially made up of extremely mature individuals so a regular intake is fairly mandatory.

Tell them that you have an article already prepared for the local community news paper (see website on how to write this feature) and that just going ahead with this venture will surely net them additional membership as a result of all the publicity.

You need to sell four prints to each of 100 club members or the equivalent, i.e. Four hundred prints in total.

So why might they be at all interested?

You have expressed an artistic interest in the visual aspects of their club. That has to please them for a start.

You've been busy creating paintings of their beloved club.

You are offering them a way to make $1500. Stress the fact that your idea will cost the club absolutely nothing and that all you need from them is a bit of painless cooperation.

Remember even prestigious old masters such as Rembrandt did exactly what you are doing here when they painted such classics as the 'Night Watch'. Each of the many people featured in that painting paid handsomely to be in the joint portrait.

Rembrandt was an artist and a business man. Art, booze and sex finally pushed business to the back seat in Rembrandt's studio. After becoming one of the richest painters in Europe he eventually died a pauper.

Never lose sight of the fact that only sensible money management can enable you to paint what you want to paint, exactly how you want to paint it and have a life too.

There is nowt wrong with brass!

If all of this seems like a bit too much work for a paltry $6000 multiply that figure by just half the number of bowling clubs in your city, say by 30. The total reward for serving just 30 clubs now looks much healthier, doesn't it, at $180,000? Not only that, you will be vastly more accomplished at painting this subject by the time you have completed this. Remember, Renoir spent years in a porcelain factory, hand painting china before he became known as a fine artist.

You will also be the owner of about 150 original paintings and have a data base of around 7500 bowling club members who might be interested in bidding at an auction for a painting depicting an aspect of their favourite pastime.

At least half of those people will already posses a limited edition print of yours, or four. So keep precise details of who buys what.

Let's say you only get an average of $500 per original painting at the auction. Personally, from my experiences, I am sure you will get more than twice that amount for each original painting that is in print but for safety sake let us err on the conservative side. 500X150 = another $75,000 when you auction the originals.

Consider the auction as a very special promotional event.

Send out at least 7500 personal invitations to just 30 club addresses and let the press know that you are having an exhibition, possibly at the wealthiest Bowling Club in your list. Don't forget to tickle the hunting instinct again, number the invitations and offer some prizes to get people along. You can afford some mouth watering prizes if you do the math.

Spend a bit on wine and cheese and flowers; let's face it you can afford to now. Bang the drum a bit.

If this whole exercise took, say two years then it would have netted you well over a quarter of a million dollars whilst you were learning the basics of the: Art of Business in the business of Art.

But wait a minute. How do you know that at least half of the club members will be interested in buying four prints of their bowling club at $20 a pop in the first place? This whole scheme depends upon the members being prepared to buy prints doesn't it?

The answer is devastatingly simple.

The club is definitely going to want the $1500 you offered them for their fund coffers and so they will definitely help the members to make the right decision.

Members already pay the club $200 per year anyway. At least half of them can cough up another $80 and even if some only buy one print, so what? You will easily sell all four hundred prints, because the club's cut of the profit depends on it.

There is however an even stronger reason that these prints of yours will sell!

Do the maths. Four hundred prints at $20 each,

equals $8000. You are getting $6000 for the work and the organising that is involved, the club is getting $1500 for being helpful and so there is still $500 left in the kitty!

That's right there are still $500 promotional dollars left. We can actually offer two or more cash prizes!

There are only four hundred prints. There may only be 100, potential prize winners in the draw.

Two rather large prizes one of $350 and one of $150 and don't forget the four prizes of expensive frames that will be given away.

All the members have to do is to buy a $20 print of their favourite club to be in the running. If they buy four prints they multiply their chances of getting a prize by a factor of four and they will have a nice matching set to hang on their wall to boot. People love complete sets of things. The odds are very favourable for each prospect to get a win here (six prizes and only one hundred prospects) and anyway their very own club is going to benefit so much from all of this that they would be really mean not to get into the spirit of the thing.

Four of the prints will already be sumptuously framed. They need to see them framed because the prints will definitely look well worth the outlay of $20 once they are framed.

Play you cards right and your local framer will give you the four frames just for the privilege of putting his little sticker on the back of each and every print that is sold. When the prizes are eventually drawn, remove the frames from your photocopied presentation group and give them to those lucky winners holding the signed and numbered, limited edition prints.

Are the members who buy prints going to get them

framed and then hang them in their homes? You bet they are.

Don't forget that since the article appeared in the local community newspaper, hopefully with pics. Those club members who now own prints own something relatively, (in the local market), famous. Don't forget to give the club the kudos for the bright idea.

When friends visit they can show them proudly and even point to a copy of the newspaper article.

They now own something significant.

Is the framer very interested in producing a run of four hundred frames?

You have to believe it.

Can the framer make a bigger profit on a run of 400 than he can on piecemeal production?

Definitely; the framer can buy moulding stock in bulk and therefore at reduced cost. Not only that, the framer can take on semi-skilled labour for such repetitive business. (Pay maybe $15 per hour and charge $60 per hour)

Play your cards right here and every time you repeat the process with another club you could earn yourself additional income by asking for a two or three dollar premium for each frame the framer supplies to a club member.

Keep records of who buys what.

Some of this accounting stuff may be boring, such as keeping track of every little penny you can squeeze but it gets to be fun when you see your profits beginning to soar.

You don't have to, but you can build a business from painting, that can make you millions of dollars.

Provided you keep good records and a data base of previous customers you can not only make more money but on well documented track records, you can borrow money to invest when you move on to bigger ideas.

The secret of business is all in the record keeping.

Whilst we are on the subject, networking is what really makes a business fly. Don't forget to get the maximum information about everyone you deal with. Even if they are just Joe Blow they might just know Kerry Packer. So chat to them and then make notes on the card you assign in your record file for each customer you serve.

If the idea of keeping such meticulous records distresses you I have to wonder why you are reading a book called, "The Art of Business in the business of Art."

I married a natural, died in the wool accountant. She loves keeping records, she is totally amazing. My wife seems to know everything and keep track of everything.

I feel that I know very little except how to paint and how to turn a profit from it. Without her accounting I would still be losing money hand over fist.

Get married to an accountant, they are not as bad as they are made out to be.

Work like this for a couple of years and trips to Florence or Venice or Rome will be well within your reach.

Imagine what studying the old masters, in the flesh, can do for your painting skill and your reputation.

Basically everything you do in regard to the Business of Art can result in building a brand name for

yourself.

Properly managed a brand name can become a gold mine.

The joy in this type of work is that although it is work and sometimes you will just not feel like doing it, it is above all, work that helps you grow as an artist.

Work for someone else just doing a job to pay the bills and you sell your time but you won't grow at the rate that would be best for you, unless of course you are a research chemist or someone similar.

So what can we take home from this chapter?
1. Clubs large and small are a great market for your prints
2. The local bowling club is an excellent first prospect
3. Only do business with the club secretary but chat to everyone
4. Only show framed prints during negotiations
5. Never pay for frames
6. Focus on subject matter you are confident with and enjoy doing the painting
7. Use a restricted palette and consider how the prints will hang as a group
8. Be sure to point out the promotional benefits to the club of pursuing this draw and getting it into the local rag
9. Create a goldmine data base of everyone you contact
10. Send invitations to your exhibition to all of the clubs and let them do the final distribution to members
11. Don't forget the hunter gatherer instinct, number

each invitation and offer prizes for the club and for the membership that attend
12. Give the club the kudos in your news article for the bright fund raising idea
13. Engage a book keeper to keep lots of records for you
14. Be consciously building a network of business associates and customers
15. Build your name as a brand.

8

The School Centenary Print

Another great idea is the school centenary print, or fifty year anniversary print or school closing down print or whatever.

Scotch College in Claremont, Western Australia is a school with an enviable image. Certainty about privilege is one of the components that education in this school endows upon its pupils. They know that they have the right to riches, so no one and nothing is going to stop them getting rich but themselves.

For such a school the idea of producing a print that depicts a composite of aspects of the school's history and daily life is a compelling one especially in its centenary year.

The school was founded in 1897 and as such is one of the oldest in the state.

The school has a magazine called the Clan. Copies are regularly sent to all current and previous staff and students. Imagine the mailing list of potential purchasers for such a centenary print. Wow, this has to be a marketer's dream!

When I suggested the idea to the marketing manager he already had a painting in the pipeline for that very purpose but the quality of the art work was painful. It had been produced by an artistic and well intentioned mum and he had almost shelved the idea. I produced a couple of watercolours on spec and

managed to persuade the guy to go with me as artist/designer for a centenary print.

Probably my relief at overcoming what appeared to be an almost invincible and entrenched competitor had softened my brain but I allowed the marketing manager to control the marketing for this venture.

You may think me conceited here but to my mind the marketing manager of a posh private school would certainly not understand even the basics of marketing a limited edition, water colour print.

It is not that I didn't make any money by creating the centenary print. I just wasn't able to make even a decent fraction of the sales that this unique situation could have provided. So learn from my mistake.

150 wealthy boys graduated each year from that school. The school had been running for 100 years, so ten years of graduates and their families was just a small sample of the community that had accrued like luxuriant moss around its hallowed halls.

When it was already too late to do anything about it I realised that the total marketing effort by the man in charge of marketing, was having 1500 A4 advertising leaflets printed, and these leaflets bunged into copies of the next issue of the Clan magazine! That was it! Well not quite, he even offered an early bird reduction!

Can you believe that? We sold less than half of the prints that I had laboriously numbered and signed.

Until you have to write a signature 1000 times and make each look substantially the same, you can't begin to know how hard it was to do that.

So what was wrong with this offering? On the surface I suppose it seemed ok, the marketing manager

was highly satisfied with it. I was on a $20 per print sold, royalty for the deal and in the end I made a measly $8000 after jumping through no end of hoops.

In all I produced sixteen paintings to produce the final print that featured parts of only five of them. I actually sold all of the paintings on top of the $8000 and got a series of other lucrative commissions that kept me working for more than a year, but that was not the point. A massive marketing opportunity had been totally squandered!

So how should the offer have been managed to maximize profit? One of the small drawbacks to working with a wealthy school is that when it comes to projects like this they are not profit oriented because they are already making a mint out of their regular business. It is just vanity publishing on a large scale.

Instead of the glossy, coloured leaflet describing and depicting the print offering, I would have spent the money used and a little bit more, to produce and mail, an apparently handwritten letter to each of the approximately ten thousand families strongly associated with the college.

The Clan magazine that carried the leaflet was free, sent out quarterly, seldom read from cover to cover and quite the wrong medium to excite interest in a commercially significant offering.

The early bird 20% reduction offer cheapened the whole thing and made the reader perceive the print as nothing more than a piece of tatty memorabilia. The wording in the pamphlet was all about the print and artist and little about the school, their school, and its wonderful history and of course the potential buyers'

part in it.

A letter would have been seen as personal. It would have drawn the link between the school's prestigious history and the families that had supported the school over the past 100 years. The letter would have apologised that only one thousand signed prints were available considering the thousands of people that for years past and present had been closely associated with Scotch College. Many of the most prominent families in the Perth business Community had been pupils or parents of pupils of the school.

This apology would have stated that because of the small number of prints available only the first 1000 respondents would be able to acquire this wonderful memorial print.

The letter, printed in black and white or better still sepia and cream (water colours usually print well in monotone), could have contained a web address where the full coloured print could have been viewed in detail. Even in 1997 professional photographers, such as those retained by the college, would have been using 30 mega pixel digital backs on their cameras and so the computer images would have been available for full sized scrutiny.

The carefully crafted personal letter, the sepia and cream image and the website would have produced thousands of hopeful responses and requests for the prints.

So what about the disappointed ones? Wouldn't it have been bad to disappoint so many people so important to the school?

Not in the least!

It would have given the school an amazing marketing opportunity to strengthen the school's bond with the unfortunate ones. If you recall there were sixteen paintings produced for possible inclusion in the final print. Limited edition prints of these could have been made and sold just to keep these lovely people happy. Instead of the $8000 I received I could have got the $20,000 I was expecting from the original print and another $20,000 at least for prints sold to those who missed the original offering. On top of that I would have connected with and painted commissions for a much larger group of clients.

But a factor was missing, a factor that would have guaranteed a feeding frenzy in this restricted and highly charged, privileged environment. To cap it all instead of making a mouth watering offer (soon to be described) that upped the excitement, the marketing manager diluted that excitement even further for the few who actually read the leaflet by offering to sell cheap to early birds.

These prospects were not cheap people, especially when it came to their beloved and prestigious Scotch College. That venerable cradle in which their off-springs' aspirations had been nurtured and assured. An early-bird discount was totally inappropriate.

So what was the missing ingredient, the magical factor? It was the magic of the gamble. Members of the human race are born hunters and gatherers. We all like to get something significant for nothing. We jump at the chance, especially when it is not going to cost us a cent. Rich people more than most like the chance of a windfall.

So if I had had control of this marketing moment I would have tastefully offered a free original painting, maybe one of the sixteen that went into the designing of the original print, to the lucky purchaser who had the winning number on their limited edition print. The same offer could have been extended to the unlucky ones who told us that they were ready to buy a print but didn't get their bid in soon enough. It might even have been worth offering a free family portrait to the owner of the luckily numbered limited edition print. I like painting portraits and this might well have opened an enormously lucrative market for me.

The $8000 I eventually got could easily have turned into $80,000 and could have produced lots of pleasant publicity for the college and tons more by way of commissions for me.

Every year a school near you is reaching a significant point in its history. If you pick the bones out of my experience with Scotch College you can definitely begin to earn money and build a more powerful data base. I hope that by now the power of the data base is becoming obvious to you.

You should employ someone to keep in touch with the entire and expanding group of happy patrons who have shown interest in your work. You can afford it now. You'd be silly not to. Never lose touch with them. They are your oil well.

If you manage to persuade the school to go with idea of an anniversary print, don't let the school take charge of the marketing, tell them that as you have experience in marketing prints you will do all the work for them and guarantee a good result.

Remember:
1. The thirsty crowd of prospects can be larger by several times than the actual offering if you communicate correctly.
2. You will quickly apologise to those who applied and were unsuccessful and offer them something just as compelling.
3. Always design the hunter gatherer factor into your offerings with a splendid lottery prize. Short odds are always irresistible.
4. Keep adding to your data base of previous customers or interested parties.
5. Don't forget that the most important person in all of your activity, by a very long way, is your customer. (The school is your customer and the parent or other purchaser is too)

You don't have to limit your memorial or centenary print to schools and colleges. Look around at clubs, local government councils, local manufacturers, pubs (after all a print costs no more than a couple of beers), ballrooms, or yacht clubs.

Have a look at my Centenary Print on my web site to see a well designed poster showing aspects of Scotch College Perth.

9

From Selling Prints to Publishing Calendars.

You probably have by now, got a few bob under your belt from painting, printing and selling your work.

The next step towards a profitable and productive arts life style could be that of going into publishing.

That is what I did, but by now you may feel that the initial boost you got from selling a piece of work for thousands instead of hundreds of dollars has given you tons of great ideas. Fantastic! Go for them!

I will tell you how I got into publishing and outline some of the pitfalls I faced. A glance through the mistakes I made might help you to stay profitable and sane.

I had discovered and exploited a market for paintings and prints of well know local beauty spots. I was still selling prints after the ten thousand dollar painting. Selling prints is the same as printing money, almost.

Getting to know your market by selling through lots of little shops is good. You can talk candidly to small shop owners and get valuable feedback.

My next big idea gave me the unlooked for opportunity to talk directly to thousands of people who bought my work and even more people who didn't want to buy my work. This was a valuable if painful

marketing exercise.

Up until the late sixties my home town of Swansea had been served by the oldest passenger railway in the world! That's right, the Mumbles Railway, God bless it, started life before the steam train was ever invented.

Passengers were being hauled along a railway that ran around the bay from Swansea Town to Mumbles Head as early as the 17th century! At first they were carried in horse drawn rolling stock, then by steam powered engines and finally by the largest electric trams ever built.

This iconic railway was bought and torn up by the owners of the local bus company in 1969, much to the chagrin of ordinary Swansea folk.

Visiting the village of Mumbles, even in the 21st century, a visitor might be forgiven for thinking that the trains still run because their images are printed everywhere on memorabilia etc.

Because of this enormous ground swell of local sentiment for the 'Mumbles Train', as it was locally known, I knew that a 'Mumbles Train calendar' would be a definite seller.

So I began to plan my first genuine publication and it was great fun.

By now I could afford to publish such a calendar on spec. However to limit my expenditure up front I sold advertising space in the back of the calendar.

Had I been smart enough and patient enough at the time I might also have received a grant from the Welsh Tourist Board but my business mind was still dominated by my creative urges and time was short.

Each of the stations on the route had had evocative

names such as Oyster-mouth Station, Mumbles Pier, West Cross etc. and these names had been cast into iron nameplates that were as familiar to Swansea people as London Street names such as 'Abbey Road', have become to the rest of the world.

I painted six watercolours of the Train at various locations along the route and printed a selection of what looked exactly like cast iron, station nameplates one for each page of the calendar.

I decided to print the cover border with the distinctive post office red livery of the Mumbles Train and the picture within the border in monochrome.

All the prints inside were in full colour and the frontal monochrome was reproduced in colour on the first page inside. I had an oval cut through the monochrome cover print to reveal the full colour of the Train on the inside front print. See website pictures

When the Mumbles Train had been in commission, black and white photographs were the norm so I figured that having a black and white print on the front and piercing it to show the coloured train on the first page would be neat.

Just opting for that attractive artistic device cost an extra $1500!

I mention this detail because it is typical of the battle between the accountant and the artist. When you are wearing both hats you also have to wear the outcome of all decisions.

In my heart I had wanted to make the front cover print sepia not black and white but to save some money I went with the latter. These days I would use sepia.

Prints of my paintings had been cheap. When I

received the first quotes for calendars I was appalled! Finishing is the process of taking printed A1 sheets and turning them into an A4 calendar.

'Finishing', almost finished the enterprise at the quotation stage. Calendars were costing eight times as much as the same number of prints! I was looking at a total of $6000 for 5000 calendars!

I can never step back from a challenge. That is just the way I am, I would hate myself if I gave up an idea just because it looked like it *might not* be feasible.

Finishing merely involved taking the cut printed pages, putting them in order, (collating was the technical term) and then spiral binding them and just that simple set of tasks was going to cost me more than four thousand dollars!

I decided that as a family we would do that much.

The first task would be the collating, just eight pages to be put in order, including the front and back covers, no big deal.

You have probably never seen 40,000 sheets of 125 g.s.m. art paper, I hadn't! To give you an idea of what that quantity looks like 500 sheets of 80 g.s.m. photocopy paper make up one of those packs you can buy in the super market. One of those is roughly half the size of 500 sheets of 125 g.s.m. Imagine then 4000 reams of photocopying paper arriving at your door, eight different colours and they all have to be opened and then put into packs of eight in a specific colour order.

One of the more printable remarks made by my loyal spouse was that we would be at it 'until Christmas'. For the first time I recognised that not only

was this collation, a task for tooled up professionals but also, chillingly, calendars have a definite use by date, Christmas!).

When things go wrong, the guts tighten, every problem begins to assume fearful proportions and the "abandon ship instinct", tries to take you.

Now how are you feeling about going into amateur publishing? Wait it gets worse!

The materials were sent to the finishers and the money was paid.

The initial delivery of loose sheets had prepared me somewhat for a returning avalanche but the arrival of twenty five, heavy cardboard boxes was somewhat intimidating.

I was far from overawed however because before launching on the project I had done a little market research.

Marketing research costs every business person; use it or not. If you use it, you pay up front. If you fail to use it you pay in lost sales and dumped, out of date goods, etc.

I had done my own market research!

Every major book, card and newspaper shop that I contacted assured me that they would be prepared to sell my calendars at about $10 retail each.

According to size of each establishment I estimated, how many of my calendars each shop would take.

For example I had put WH Smith down for at least a hundred at $6 each, wholesale. They were a large national company with massive sales around Christmas time.

My research suggested to me that I should break

even, shortly after receipt of the calendars in June and still have about 3000 left to sell.

As soon as the boxes arrived I put three in the car and set off to unload them upon my grateful retail customers.

I proudly showed my handsome product to the retail manager for WH Smith and asked how many he would take on the sixty days credit we had previously agreed.

"Twelve", was the shocking reply!

I looked around the large and busy shop in disbelief.

The manager explained that as WH Smith was a national franchise operation, apart from a very minor budget, all stock was purchased nationally by head office in Manchester.

Not many people in Manchester had heard of Swansea, never mind Mumbles so a calendar about a seaside railway that had closed twenty years ago was not going to get the head office's approval.

By the end of the first week after receipt of the boxes I had earned $1200 in sales and about $800 from advertising and my hallway was jammed with heavy cardboard boxes.

Not only that, my initial enthusiasm for the idea of calendars had inspired me to put six of my Gower beaches type paintings into a second calendar. Four thousand of those calendars arrived about two weeks after my Mumbles Railway edition.

My hallway now looked and sounded like the entrance shaft to an Egyptian tomb. It's amazing how lots of very heavy boxes can change the acoustics of a

space. I was being buried alive under the fruits of my imagination.

Drastic action was needed. The thought of binning any of those lovely calendars was too much to bear. If the shops wouldn't take enough of them then I would sell direct.

Even in June, Swansea gets a lot of wet weather and I had rapidly worked out that, to sell the eight thousand calendars I needed to save from the bin, I would have to sell more than 50 a day right up until Christmas! That was a staggering figure for a person who'd never before been involved in direct selling.

I got one copy of each calendar laminated, see photos on website, and bought myself a white, waterproof outfit that made me look like the ghost of some lost lifeboat man. Especially when the rain was chucking it down, the wind was blowing and the orange street lighting was throwing a dark shadow under the wide brim of my white Sou'wester.

Of course I had all of my little retail shops to help me up until the end of summer but they generally closed during the winter, apart from a few rural post offices.

I fixed on a target of forty sales per day. Ambitious I know but in the circs?

The very first day I went out, to do door to door selling, I was a bag of nerves. I chose a quiet street in a working class district.

What I am about to relate actually happened exactly as I tell it.

The wrecked motorbike in the overgrown front garden should have given me a bit of a warning but I

was absolutely focussed on tackling every house in the streets of that district until I had sold my forty for the day.

I had five calendars in my hand. I knocked the door and waited. I knew that there was someone in because a sort of rumbling noise came from within, directly after my knocking.

Before I could blink the door was torn open and a wild man was screaming in my face that if I ever tried to sell him anything at the door again I would regret it!

I staggered backwards to the pavement, somewhat stunned.

I figured that nothing else could be as bad as that so I shakily crossed the road to a very neat little front garden, went up the path and knocked the door.

Eventually it opened and a little old lady smiled out at me.

I had not yet worked out a sales pitch. I held up the calendars and said, *"...they are calendars."*

"Are they, love?" she said, *"How much do you want for them then?"*

"Four pounds", I said. (That was about ten dollars)

She bought two! Half way up this cul-de-sac I had sold all five calendars.

I walked back to the car to get ten more just in case.

I actually sold eleven in that one street.

Each day, every day of the week I visited on average 100 houses and I sold my forty calendars. Some people bought more than one. One chap bought eighteen, said they would be Christmas presents for his staff.

I knocked on one door and sold a calendar. The

next week there was an article in the local rag amusedly recounting how Christmas seemed to be coming earlier each year. The paper was very kind about my calendar and that was a little boost to my self esteem and made me feel better about door to door selling.

I can't go through all of the amazing contacts I made by selling door to door but I must tell you about one incident because it underlines what can happen if you have the courage and tenacity to really push the boat out in direct selling. Though much maligned, direct, door to door selling is the very best sales academy there is.

A couple of months down the track and more than 2000 calendars sold I was getting pretty good at summing people up and my selling rate had become very good. I knocked the door of a fairly smart looking house.

Doing the hard yards I had discovered that owners of posh houses were the least likely to purchase anything at the door. I happened to be passing this one, had one calendar to sell for my forty for the day, so I gave it a whirl anyway.

A dapper little man came to the door. I told him that I was the artist who had painted the illustrations in the calendar and that I was selling it door to door.

"Come in for a minute", he said smiling.

Reluctantly I edged through the door.

"Have a seat, would you like a coffee or something stronger?"

I perched politely on the edge of a pink velvet sofa but refused a drink.

This guy sat on the other end of the sofa. I felt

uncomfortable.

He smiled at my obvious nervousness.

"Got any other examples of your work?"

"What is your interest?" I heard myself asking.

"Good question. Mrs Thatcher has asked me to use my business experience to make each hospital in West Glamorgan, make a substantial contribution toward the cost of running its services. She has charged me with bringing suitable retail enterprises into the entrance halls of the 36 hospitals in my district. So far I have only managed to get a florist to set up a small counter in a few of them. How would you like to have 36 print galleries? We will provide the furniture such as a table for order forms etc if you can provide folding screens on which to display your work. Pick up the completed order forms daily and deliver the goods and collect the money during the next couple of days. How would that appeal?"

I was gob smacked!

That very week I hired a cabinet maker, he made and erected the zigzag screens and helped with the maintenance and with the deliveries and I carried on selling my calendars door to door.

The photos of Roy Kieft Galleries are on my website.

I now had more little galleries than I could supply with prints and calendars and cards.

I found that by cutting the most popular prints from the calendars I could actually make more money selling them as prints than selling them in calendars.

This discovery took away all of the pressure to sell my calendars by Christmas, as any calendars not sold could become a source of prints and actually make more

money than calendars.

So why did I go on selling my calendars if there was more money to be made in prints?

Excellent question.

When I set myself a target I hate to abandon it for any reason, good or bad. Not only that but each and every calendar had in it, an A4 promotional sheet. This sheet advertised the forth coming exhibition of all my unsold original work plus an auction for the twelve original paintings that illustrated the two calendars.

The venue was to be a hotel that featured prominently in one of my illustrations and once again we were moving into the old win-win formula for advancing one's career. The hotel would benefit immensely from having the auction and exhibition in its conference facility and so a very equitable deal was struck regarding food, wine, flowers and room rental.

As an artist my overall strategy was to increase the number of people who had heard of me and who owned prints and originals of my work. Calendars are more prestigious than straight forward prints.

Owning a publishing company is much more up market than merely getting one's paintings put into print. Not only that, once you are a publisher you don't have to do all of the painting yourself.

As an artist you will soon find that no matter how prolific you become there are only so many hours in the day. If, on the other hand you can enjoy doing the occasional painting and help other artists to become recognised in the process then the sky is the limit.

Not doing the physical work one's self is always the most direct route to financial freedom.

Reading this book there are a few things that you should have picked up. Check out the following:

People buy emotionally but they need a rational reason before they allow themselves to make a purchase. Some guy buys himself a flash car because emotionally he loves the look of it. Rationally he will explain that the image the car gives him is necessary for the good of his business. The flash looking car will make people see his business in a very good light, he explains.

People might buy prints from you emotionally, simply because you are a gorgeous human being. That would work and often does. It is safer, however, to give them something other than the brilliance of your print and personality as an excuse. So you had better tie their decision to something they really like; helping a club raise funds etc.

Then you reinforce their decision with a bit of a gamble; the limited edition print\raffle ticket is perfect for this. They can see that they could easily get back much more than they spent.

They are getting something much better than a raffle ticket and it is still an item of value after the draw is over. People have to feel and be able to explain when called upon to, that their purchase was sensible for a number of reasons. A) They liked your print. B) Their money helped their club. C) The odds of winning something were much better than they usually are in a raffle.

As your work becomes widely known and collectable the intrinsic value of your prints becomes an investment that will accrue in value. That of course is

the perfect rational excuse for paying an inordinate amount of money for a limited edition print or even for an original.

In my next book I will show you how to move towards becoming highly collectable even in your own life time.

Being afraid to die is understandable.
Being afraid to live is tragic!

Good luck with your first $10,000 painting.

10

Candle Making; Making an Income to Support Your Art.

You may feel right now that your work, the work that you love doing is not actually suitable for printing and selling for clubs etc.

I made candles when times were tough and discovered a very good market for a certain type of candle.

This chapter shows you that if you bring a business mind to bear on the candle making, arty type, cottage industry, large profits can accrue.

There are very few entry barriers to candle making. The business problems associated with this cottage industry are a good place to pick up some rudimentary skills without the fear of bankruptcy.

At one time I was sharing a house, as students do, with a group that did a moonlight flit. To pay the rent for the house, already owed and for the next couple of months, I needed an extra income because I was a full time college student. I needed to make something that was easy to make, from cheap materials and would sell well in November and December. I chose candles.

Make good money, by making candles and selling them.

This chapter may be of little use or interest to you. It details how I, as a student funded my way through college and made more than enough to live on whilst I studied.

Approached in a business like way candle making can be very profitable and provide the money you need to more than just survive as a student.

The raw materials are cheap and your overheads will not include transporting heavy goods from China.

Most candle making is an automated pouring and casting process so labour costs are not really that important. This may give you a fairly level playing field because the cheapness of Chinese imports is due to the cheapness of labour in China. If all that you want is a modest income as you study or paint then a few hours of work a week can get you a substantial income if you plan it properly.

Christmas was about three months away when I was left with all of the house bills by a couple who had agreed to share but had done a moonlight flit. People were already thinking of buying Christmas presents because the shops were telling them to.

Not far from the house we were renting was a large Sunday market.

The cost per table was about ten quid. We used a wall papering table draped with a green velvet cloth to display our candles.

At first I stood behind our delightful display and

waited for people to buy. No one did!

Our candles were reasonably priced and good to look at. I had hit upon a design that would cost little to produce and yet look worth quite a bit and be acceptable on any table or mantelpiece. See website.

I had bought a hundred plastic tumblers to use as moulds. The sides were vertical and there was a step about 10mm from the bottom that made the bottom about 5mm narrower in diameter than the main body of the tumbler.

I bought some odd rolls of anaglypta wall paper which is a heavy glossy embossed paper with patterns impressed into it.

From the roll I cut collars of the patterned wallpaper and fitted them into the tumblers so that they were the depth of the wider body of the tumbler and rested on the 5mm step.

A small hole, drilled in the centre of the bottom of the tumbler accepted one end of the wick and the other end was held by a cocktail stick resting across the top of the tumbler.

The hole in the bottom was sealed with blue tack and the coloured wax was poured into the tumbler, topped up occasionally when a depression formed in what was to become the bottom of the candle. Wax shrinks as it cools.

The candles fell from the tumblers because the stearic acid we mixed with the candle wax caused the wax to shrink away from the sides of the tumbler as it cooled.

Once the candle was out, the paper was removed leaving a rough looking pattern wrapped around the

main body of the candle and a shiny coloured top, (complete with protruding wick) that had formed in the narrower bottom of the tumbler.

This rough pattern of roses and leaves and thorns was finger rubbed with gold paint. The resulting object looked like a glossy, coloured candle nestling inside a carved, golden candle holder.

Once these beautifully coloured objects were wrapped in cellophane the result with a gold label sticker with our name and phone number on the bottom, they looked very professional and attractive.

So off to market we went.

As I said, I just stood behind the table for the first hour, smiling at any one intrepid enough to approach our table. This effort resulted in no sales. For a while I admit it looked as if we'd lost the ten quid entrance fee and the money we had gambled on our supply of wax as well.

Desperation forced me to leave my side of the table, wander around to the customer side of the business and pick up a couple of our lovely candles and look at them.

As a couple of women were passing I offered them a candle each. I said something like *"Look I've only got these few left,"* there were a load in a box in the boot of my car actually, *"I want to get away soon so I'll let you have them for half price if you buy one each."*

It was my first ever sales patter and it worked. Maybe our original price had been a bit too optimistic anyway.

Whatever the cause, dropping the price and working at the customer's side of the counter and actually talking to people worked.

Before long I had little crowd eager to get their inexpensive Christmas present bargains from me. Within an hour and a half I had sold a week's candle making and was packing up to go home.

As Christmas got nearer I started selling sets of coloured candles around the doors of the neighbourhood too. I did this by putting together a display case with six candles in it, knocking doors and taking orders. I would then deliver the orders during the following week.

Christmas comes and Christmas goes but the rent has got to be paid all year around.

This crisis was typical of the student's lot. Four of us had rented a house to share and two students disappeared one night with rent owing and leaving just two of us to find the entire rent. We had quite liked the pair who "done us wrong", so finding someone else to share, mid term was not only difficult but unattractive to us. We quite enjoyed having the whole house and by now the garage was sheltering a full blown candle factory.

So what to do after Christmas? What celebration goes on all year round?

Birthdays, that's it!

We invented the birthday number candle.

Yes, I've seen the piddling little candles in the shape of a number that lie on top of a birthday cake. Our birthday number candles were no such insipid creations.

Firstly they were very three dimensional and very big and stood tall. They were giant wax numbers that the kids absolutely loved.

Make your number candles large. Say six inches tall, 150mm. Let them have a printed card base saying "happy 2nd birthday", or "You are two" or something. Make them in primary colours. Emboss them, do fun things with them. When they appear on a party table your target market is looking at them.

I guess every one has heard of selling by party plan. We might have invented that idea too because as kids rolled up to the birthday party they'd been invited to and witnessed their friend trying to blow out a huge 2, 3, 4, 5,6 or 7 number candle they wanted to have a go as well!

Why not offer them as a novelty gift to venues that cater for parties; McDonalds, Pizza Hut, the local... what ever. Card shops and cake shops will definitely take them on sale or return. Call yourself ABC, Australian Birthday Candles, Asian Birthday Candles, Anglo Birthday Candles, American Birthday Candles or even Aardvark Birthday Candles. ABC is a good name for a candle company that is interested in making big interesting and educational candles that look like 1,2,3. etc.

Our birthday candles were madly coloured. They were striped, dotted, candy colours and primary colours. Our birthday candles were riotous.

Each monster candle was almost half as big as the cake.

If you think that kiddies were the only ones that wanted our birthday number candles you are wrong baby.

Ever tried to light and blow out twenty one candles without getting wax on the cake?

That's right, what could be more useful for yuppies at a party than a pair of candles that said thirty five or twenty eight or even 100?

When you really get into this thing and start putting your numbers in grown up looking, wooden boxes with transparent front sliding doors and all manner of greetings stamped and dribbled and sprayed on them, then the sky's the limit.

Those candles kept us going through college. I was really surprised that no one ever copied us but they never did. You could though!

So if you have to make a few bob in college or you want to support your art work with something other than prints, this is what you need to know about making candles.

- They have to be uniform and of good quality to sell.
- Buy your candle wax and your stearic acid from an industrial chemist. The softer wax is the cheapest, so use that.
- Wax dyes go a long, long way so don't buy too much of each colour.
- Melt the stearic acid and scrape the colour into it.
- Pour this coloured mixture into the molten wax.
- Be careful not to get the wax so hot that it smokes.
- Try not to drip it on the floor; it soon picks up dirt and looks terrible.
- Make the numbers about three inches thick and nine inches tall.
- Make them in horizontal metal moulds with the wick stretched horizontally from the top of the candle mould too the foot.
- Experiment with layers of different colours giving a

candy stripe effect and then go berserk.
- To get a good finish on a candle that has been poured into a horizontal mould make sure that the number, as you wish to look at it, is face down and it is the back of the number that you will top up as the wax shrinks.
- You can place a patterned flat plate in the mould so that you pour the wax on top of it and end up with a pattern in the face of the large number.
- Finish the candle by dipping it in hot clear wax. To do this hold the wick and dunk it in a vat of hot wax. This process will smooth any rough edges that resulted from the horizontal pour.

It may not become a fully fledged business. That will be up to you, but you can certainly make a good living from candle making in times of need.

Wrapped candles look ten times more valuable than bare candles.

A label, silver or gold, not only looks professional but it gives the purchaser a means of contacting you and re-ordering.

A well organised set up can produce enough candles with two people working over a period of eight hours to keep you both in money for several weeks.

If Christmas markets are not current then the party plan, number candle will take a little while to produce a similar level of sales but the margin you can get for unusual, kid and yuppie, birthday candles will be much better than for the ordinary decorative candles you market as Christmas presents.

Card shops and newsagents are everywhere. Even if you have to sell the first few on commission, (you get paid when they sell) to these shops you can soon establish quite a repeat business.

The internet is a good idea but these are heavy items so shops are a better bet if you are only looking to make a couple of thousand dollars a week.

Anyway you don't want everybody making your designs, do you?

There are one or two other feasts that candles are appropriate for: Easter and Hanukah, Divhali and the Moslem feast of Eid at the end of Ramadan.

11

Metalkits; Turning Metal Sculpture into Gold

Once a child came along the heady milieux of the pop concert business and the late, late hours became impractical. After my darling baby Amy had slept in her Moses basket under the cast iron tables of the majority of Chelsea pubs I decided to quit Obadiah's Gasworks. I bought a house in Lowestoft and took a job teaching because I still did not consider that I could make good money from Art.

An ordinary marriage and two lovely children later, the Obadiah's Gasworks' Champagne Breakfasts, of the heady Seventies had become but a dim memory and I was again in financial strife.

We were so poor this time that we could not afford to buy a wood burning stove to keep our tiny, cold, house, warm. Free drift wood regularly piled itself onto the frigid Lowestoft beach only a hundred yards away from the house but we had to burn it very rapidly, dangerously and wastefully in the open grate.

I was unable to even afford a wood stove that would conserve wood and produce more heat!

The higher you climb the harder you can fall. I never bought us a parachute with the money from the Gas Works but at least I bought a tiny house. The guy, or was it his wife, had had some sense.

The guy now had a job! Can you believe that? He was an art teacher earning a pittance, after being able to buy a decent Jag from one week's earnings as a pop music, business man.

Don't shake your head at my story. Getting that working class pattern out of my heart and head took a lot of practice and I had to understand that it was in there before I could do anything about it! At that time I simply didn't believe that I had a right to riches.

My first Jaguar car was not an E type like Hugh's, but a metallic blue, 3.8, mark 2 saloon, with walnut and leather trim. I had bought this piece of mechanical joy second hand from a Wing Commander. (Well, Hugh's E Type Jag had been second hand too.)

It cost just one week's earnings from the Gasworks. In Lowestoft I was now driving an eleven hundred Ford Escort with a thirteen hundred engine and the original radiator. The radiator boiled if we stood still in traffic for more than five minutes!

"Hey I'm resilient! I can make a come back!" The wife and kids will understand if I'm out all night or even all weekend earning money in London night clubs whilst they are cold and lonely in the small house in Lowestoft, won't they?

No they won't.

We really needed a wood stove. I can make anything right? I had made lutes and harpsichords in London, mended priceless antique instruments for the Victoria and Albert Museum when things were looking up and I had had plenty of confidence.

I'll buy a welder. Make a stove, sell the welder and Bingo! We have a stove for the cost of the steel, which at

the time was cheap as chips! Hey wait a minute. I could even make two stoves, sell one and keep one free and clear!

This guy is just a natural business person you cry. Not so, at least not yet. Business people think and plan, they rarely make things, they get others to do all of that and in the end, by organising, buying and selling, they own what they want free and clear but they never have to make it themselves.

We artists have a bit to learn about the genius of the true business mind set. We, however, do love making things. It is what we do best. We just have to learn how to make the art produce an income stream after we have made it.

I still had a great deal to learn and I loved making things so……..

The following is an account of this first ever, serious business adventure of mine. It might be useful for you to see the how I began an entrepreneurial career and though I was teaching art at the time and was quite artistic, the thought of making money from art never entered my head until decades later.

I just discovered the truth that people, ordinary people, can make real money with a bit of enterprise. This set me off on a pathway to economic, self sufficiency.

Metal sculpture and wood burning stoves.

Wood burning stoves took a big hit when global warming was beginning to be attributed to green house

gas emissions. They were even banned in some jurisdictions.

Subsequently it has become clear that the humble wood burning stove has a smaller carbon footprint (forgive the cliché\pun please) than any of its counterparts such as gas or electric or coal heating.

If you like to produce iron art or steel sculpture and not just painting you might also be prepared to produce utilitarian products that can bring you a sizeable income stream on the side. You can then earn a good living whilst you are creating your metallic art.

From making a couple of wood burning stoves I developed a business called Metalkits.

One of my headline adverts for this, my first ever, proper business venture was

"Own a welder? Make it pay!"

Placed in a British trading paper called Exchange & Mart this, six word advert, brought a trickle and then an avalanche of envelopes stuffed with money, through my letterbox.

The fact is that you do not need a welder to create a stove from steel sheets but when I thought up the idea, I guessed (correctly), that there were thousands of people with welders who had no idea what to do with their shiny new welder once that first job was done and the lust to own the toy had been slaked.

Stoves can be bolted together. But the money rolled in from would be welders, anyway.

Once you know how to make a simple wood

burning stove, for an artist\sculptor, variations on the theme can be endless.

I was a first year art teacher. I had a wife and two children, our first house and no money. Children need a full time parent when they are young. My wife preferred to take the role of full time parent, and we were managing on my income and a bit of government 'family allowance'.

I perused catalogues and examined physical examples of stoves in shops. This research provided me with the simple mechanics of the wood burning stove. Perhaps I was a bit naive in the way I went at it.

Nowadays I would organise things differently. Thirty years of experience changes one's thinking.

My first serious mistake was in the choice of a welder. Knowing little about arc welding, other than that it was dead easy to do, ha, ha, I chose the cheapest one available.

My little welding plant looked terrific, better looking in fact than the more expensive models, and the carton openly stated that it was so simple, even a novice could operate it!

There were two contacts for the leads plus an on\off switch. None of that complicated looking, knob twisting stuff that other welders sported. It was less than half the price of the next model up and so light that I could carry it with one hand, in short it was perfect!

If you are skilled in welding you are probably already grinning. My cheap welder with the on/off control, proved to be very difficult to use.

The current it generated was so weak that only a rod the size of a sparkler could be fitted into its rod

holder.

This machine was very good at sticking a welding rod to any metal it came near. Rod and metal would proceed to get red hot and I would find myself yanking the thing around and spraying sparks and swear words in angry panic.

The welder would overheat and switch itself off for ten minutes. When I mastered the thing it would weld for five minutes and rest for ten. This pretty little welder was practically useless for anything except making sparks.

My second big mistake: Choice of work space.

Remember, this was my first business and I was young and knew everything. At this point I also had no intention of turning my efforts into a full blown, money making, business.

I reasoned that the bathroom would be the safest place to do the welding. Ceramic tiles on floor and walls were fire proof. I balanced a piece of steel chequer plate across the vitreous enamel bathtub, and so created a perfectly fire-proof welding bench. It was a bit too low for comfort but it was safe enough.

After much practice I managed to use my tiny welding rod, or as a welder friend later described it, my 'fairy wand', to stick bits of steel together quite firmly with a lumpy, fragile glue of metal and flux inclusion.

During the process the sparks generated, embedded tiny droplets of molten steel in the enamel of the bath and the glaze of the ceramic tiling.

Now I had to pay for a bathroom renovation as well as produce a wood burning stove. I really had to start making some money now!

Every crisis is also an opportunity.

I sold the little welder and bought a bigger one and mastered the use of that much more easily than I had the little one.

If you are contemplating buying a welder and know nothing about welding, get the biggest one you can afford. Beware of the arc! It can not only blind you, but sunburn you too! My hands and arms looked like they had been wrapped in loose brown paper after a few hours of welding without gauntlets.

To cover the cost of tiles and the new welder I decided that I would make two stoves, sell one and keep the other.

That first pair of stoves, though beautiful when newly finished in a black, heatproof coating, was fundamentally flawed, though I did not yet know it!

My best friend had bought and paid handsomely for the other one of that initial pair and he had been delighted with it when I had proudly delivered it to his door.

With great excitement that same evening we lit my stove for the first time. It worked very well, with the air control fully opened it gave off blistering heat and even began to glow a dull red in places. Then the stove bulged, distorted and contracted as it cooled. By the time it was cool enough to touch it looked as if it had fallen down a long flight of concrete steps.

So it was back to the drawing board, then I remembered my friend's stove. I rang him and shyly

spilled the beans.

He never, ever, lit his stove but firmly declined to swap it for a later, modified version. To this day his wife dutifully polishes it with stove blacking. It still looks really neat because it has never been lit. It stands proudly in his tidy living room, usually with a small bowl of flowers sitting on top of it.

I gradually solved all the design problems. I made a feature of the main solution which was to weld a pattern of ornamental fins to the flat sides of my stoves. These fins could be curved to resemble flames or waves or rising heat. They looked great and they stopped the sheet steel from buckling. They also increased the surface area and allowed the stoves to emit more heat.

But this is not a book on design. If you wish to read advice on how to make steel welded wood-burning stoves that don't distort, give off tons of heat and last forever, visit my website.

The monastery at the end of the world!

Before getting on with the 'how to make money part' here is a true story.

The monastery at Crawley Downs, in Sussex, heard about my stoves and asked me to equip their entire monastery for them. By now the stoves were selling as fast as I could make them.

Something terrible happened during the process of installation which still makes me laugh and shudder at the same time. You can skip this part of the chapter if you want to get on with learning how to make money

with a welder, but I can't resist including it.

I had my own car, (a Ford Anglia), but try as I might I couldn't get the flue pipes and ten stoves into it or even on to it.

A friend had just bought himself a gorgeous collectors-car that was well up to the task. Generously he offered to lend it to me.

When I got to the Monastery I left his shiny, vintage, Humber Super Snipe shooting brake parked in the empty carriage circle. Then I unloaded and set about assembling sections of flue on the raised lawn, near the carriage circle. The birds sang, the sun shone and the peace of this sacred place seeped into me.

Deeply engrossed I had almost forgotten that the rest of the world existed, when a loud bang made me swing around!

Not expecting anything to be parked in the turning circle a monk had reversed the monastery's Ford Transit van out of the stable/ carport and straight into the front off-side wing of my friend's gorgeous old Snipe.

Unable to contain my anguish at the vision of this collision I dropped a flue pipe and yelled "Jeeeesus Chriiiiist!!!"

Monks appeared simultaneously from various buildings and gardens, only to be disappointed that nothing more significant than a very mortal visitor and somewhat bent, vintage car were on their sacred ground.

The story ended happily. The local panel beater employed his mortician's magic to the damaged bodywork of the shiny black car and the monks buffed and polished every visible clue away.

After making about a hundred stoves I began to realise that manufacturing was not where the money was in this welding game. It was hard work and I was slowly getting poisoned by fumes.

I stopped making stoves and began to make money instead.

In the UK at that time there was a publication known as Exchange & Mart. This weekly newspaper sold in millions. It was crammed with ads that included anything from porta-potties to pomegranates and everything in between. There were thirteen pages of ads for welding units and equipment. Thirteen pages!

A fool and his money....

As I looked through these pages I realised that every week, for the past goodness knows how many years, people and companies had spent hundreds and sometimes thousands of pounds advertising welders and welding equipment.

Luckily I had grown to detest the smell of welding flux burning. I looked at those tempting ads with a business eye only. I calculated that those expensive ads that had run for years, must have sold tens of thousands of welders, possibly millions.

I reasoned that many a householder had acquired a welder, done a job or two and then stored the heavy new machine in a corner and tried to forget that they had invested good money in it.

Then I authored those six words that made me tons of money.

Own a welder? Make it pay! This and a phone number, placed in the welding pages of the Exchange & Mart, and the money began to flow.

I sold plans for making wood burning stoves. I launched a company called, METALKITS and began selling pre cut metal kits for making stoves. I designed spiral staircase kits, car ramps kits etc. etc. and the money poured in. This was not self employment anymore this was business.

I even began to sell welding equipment and consumables on the same six word advertisement.

Then, being an artist at heart, I got bored with being a conduit for other people's stuff.

I designed some very opulent wood burning stoves and really enjoyed making them. Think of Faberge` and you can picture them. They were decorated with copper, brass and bronze ornaments and had coloured enamel panels and handles etc etc.

METALKITS morphed into the *'Saint Petersburg Cannon Foundry'*

I reasoned that Russia was cold and probably one of the original homes of wood burning stoves.

Saint Petersburg Canon Foundry would suggest the exotic, quality stove needed by the top end of the market.

('Lowestoft Welding Shop', wouldn't really cut it) We lived in Lowestoft when I first ran METALKITS.

I made some of these very lavish and expensive follies and even sold a few.

I guess I could have resurrected METALKITS but like Toad of Toad Hall I wanted to move on.

What can we learn from this chapter?

Even daft sounding ideas can lead to brilliant conclusions.

If you like working with your hands and can weld

you can make good money.

You can make better money by getting others to do the physical work.

Work *on* your business more than *in* your business.

A good ad is simple and sharp and pulls in tons of money.

Don't give up when things go wrong. Try to find a way around problems.

If you like to produce three dimensional metal products this might be a way forward for you.

A crisis is always an opportunity to solve problems and thus benefit.

I still remember the excitement of rushing down stairs to get the post and finding lots of handwritten envelopes, containing money, addressed to METALKITS

Become emotionally and rationally inspired enough and the world will make room for you and for your enterprise to fly. If you get nothing else from this book please get this: *how* you do something is massively more important than what that something is.

Whenever the great Violin teacher Suzuki accepted a child for tutoring, his lessons began in a most unconventional way. Suzuki spent the first few lessons teaching the child how to gracefully accept rapturous applause and encores from an audience.

The pupil; dressed in best or borrowed concert hall clothes and with an expensive violin tucked under one arm and holding the bow correctly in the other, heard the recorded sound of an audience applauding rapturously.

The pupil was taught how to bow gracefully and

receive this accolade with courtesy. Before each subsequent lesson began, this ritual was performed with care and the parents were encouraged to ensure that the ritual was observed before each home practice.

Suzuki's pupils achieved a disproportionate level of success in the world of music compared to those of other great teachers. No doubt Suzuki was a fine teacher of music and would have had successes anyway but the illustration is a useful one in that it demonstrates the power of vision.

Conventional teaching often fails to cultivate the most important ingredient for outstanding success.

That ingredient is hard to define but it includes vision, visualisation and a clear picture of where the heart is heading, where indeed the heart has got to go.

Get the heart to its destination and the body must follow!

Then that powerful, unimaginably clever brain that is at the behest of your heart will carry you to success as surely as a mother duck will paddle through burning oil to rescue her ducklings.

There are other, more cautionary sayings such as; 'be careful what you ask for because you might get it'.

I have to admit that I have acted very much like Toad of Toad Hall in my earlier dealings with life. I too often became overwhelmed practically to the point of self destruction by the wondrous power of a vision.

If you get a powerful vision make sure that you are not the only significant person in your family with that vision. The do or die passion that flows from such a vision is a tiger you have by the tail.

Make sure you have a partner that is at least

prepared to hold a glass of water to your lips when you are hanging on with both hands to the black and yellow striped leash. If you are in a firm relationship then both partners need to be almost equally committed to any vision that you have.

12

Toad Hall; Keep your Cards Close to Your Chest

Henstead Private School, Toad Row, Henstead, Suffolk was one of my do or die visions. (I've had a few.) This one followed hot on the heels of the St Petersburg Canon Foundry.

I had been teaching for a couple of years when I realised I disagreed with the way the British Educational System worked.

One day driving in the country lanes of Suffolk on my way from Beccles Market to my home in Lowestoft I came across a little village called Henstead.

When I passed through Henstead I had just auctioned some antique wooden cameras for almost five hundred quid. I was feeling very pleased with myself, very Toad of Toad Hall.

As I was leaving the main street of Henstead I drove down a lane called Toad Row because I just couldn't pas by a lane with a name like Toad Row.

The abandoned village school building I found there took my breath away. It was so attractive with its pointy Norman windows and Doorways and brick walls. Apart from the collapsing rear wall of the main hall and its rotten ten foot square timber window, the old school building was in good condition. As I walked around it all of the dreams I had ever had about

running a child centred private school welled up in me and I felt rich with five hundred quid in my pocket.

Within minutes I was excitedly asking at the local shop for information about the enchanting old school building. The only activity to take place there since the school in Toad Row had closed for lack of local children, was the weekly whist drive.

I raced back to Lowestoft in a fit of entrepreneurial infatuation. I had become Toad of Toad Row Village Hall.

After a hurried consultation with the group of teachers I wanted teaching with me I convened a meeting with the village committee. In principal it was agreed at the meeting that we could rent the school from them on a long lease, provided I made the building sound and equipped it with a couple of extra toilets. The cost of these alterations would be deducted from the rent. Effectively it would then be rent free for the first year.

I was over the moon.

In my spare time I worked like mad to make the building sound. In the prospectus we produced was a drawn picture of the delightful little school with its Norman arches at the top of the first page of text.

Upon advertising in the Lowestoft and Oulton Broad newspapers and libraries, vets and doctors waiting rooms we got a flood of enquiries. I had bought all of the desks and chairs and put in the extra toilets. We had fifty three signed up students by the end of summer.

The local authority rated the Henstead School set up as suitable for fifty pupils and eight staff. We had

fifty three pupils signed up and would begin term one with five staff. This was a fantastic ratio of approximately 10 to one. Government schools were working at a class room ratio of, 29 to one. A telephone call regarding the extra three pupils cleared the matter. As there would only be five staff they would allow us to stretch the rule to 53 children I breathed a sigh of relief. At such small numbers even a shortfall of three can make a crucial difference.

When the village committee first told me that there might be a problem with the lease I was not that worried.

When I discovered that they wanted to have three mothers from the village employed as teachers and also have their five children attend the school for free I was shocked.

Here I was putting together a team of professionals, all top class teachers that kids loved to be around and the village committee was holding me over a barrel unless I took on three primary school teachers of unknown capability and blow out the number of pupils to 58 when we were technically only equipped for 50.

The new term was to start in September of 1979. The committee told me during the August holiday break of that year that unless I acceded to their demand the lease would not get signed.

Sadly there was no way to incorporate an extra three teachers of unknown ability into an already tight business plan. Without the necessary negotiating skills and with nothing but an ethical leg to stand on I found myself unable to salvage anything but a pittance for the schools desks and chairs.

This was the ignominious defeat that nailed the coffin lid on my marriage. It didn't die immediately but was seriously short of oxygen from then on.

13

The Miniature Brickworks;
An award winning business.

I told you that some of the stuff I was going to let you in on was uncomfortable for me to confess. I am sorry to say that I was slow at finding out that in business you must keep your cards close to your chest.

Having failed at Henstead, I was relief teaching in the manual arts department at a Secondary School in Swansea.

In the process of trying to get the children to understand building science I had a thunderbolt vision, 'miniature, real bricks'. I built some models with miniature real bricks I had made and entered a local government business competition and won a place in the best business school in the UK!

I was shocked and scared. OK I knew I was good at ideas and that my Miniature Brick Company Limited, idea was good. But me, go to a top business school? I didn't think so!

There were just six of us small business people confined in this residential palace of a college; Durham University Business School.

All six of us had great business ideas and not one of us was any good at accounting.

The Miniature Brick Company Limited

I left DUBS fully equipped to start up my Miniature Brick business. The business plan was already in place. We found the perfect site for the brickworks; an abandoned munitions factory on a marsh. This was surrounded by massive dykes of solid clay!

That first factory of mine was a gorgeous building. It had been left in a relative's will to a friend of mine and I got it for a pepper corn rent.

My first and most delightful job was to paint the company name in three metre tall, white lettering, high up along the entire landward wall of the building. Driving along the estuary road people could see it for miles proclaiming itself proudly over the sullen clay embrasure.

I used the typeface 'playbill' for my headed note paper etc. because my entire marketing plan was to give everything a retro feel to it.

Just in case you stop reading after this and rush out and sell your house to fund your business heed this warning. Never sell a house if you own one or nearly own one. Don't sell it even to buy a better one. Just keep buying small until the revenue and equity from your properties allows you to buy big.

From the hot house atmosphere of the residential, intensive year at DUBS I started like a sprinter from the blocks. I was going to revolutionise manual arts teaching in the UK and much, much more.

As you can imagine, machinery needed for a 'miniature brickworks' does not come off the shelf.

Between what we had put in and borrowed as a Government Guaranteed Loan to small business we had a pot of almost 200,000 pounds sterling.

Even before going to DUBS I had hit upon the final design I was going to use for the miniature brick making machinery. So I knew I could get to the production machinery from the prototype fairly rapidly.

Our most popular item after the bricks was the miniature ceramic toilet pans with wooden seat and lid. They made intriguing paper weights and were good conversation starters.

After a year of development and commissioning, the machinery was ready and we got into production.

We began to supply schools and colleges through out the United Kingdom with a new medium for a trendy new subject area. Woodwork and Metalwork had morphed, along with fibreglass canoe building, into the 'Craft Design Technology' departments of U.K. schools.

I had decided to enter a national business competition sponsored by ITV and Lion Laboratories. I already had everything the competition required, including my business plan with actual figures alongside our projections. I contacted the secondary school I had taught at and yes they would be happy to allow the TV crews in to film the children who were using my materials there.

After six episodes on prime time TV our sales were much stronger. The competition was run to the same formula as 'Master Mind'.

The six finalists had to face a panel of judges. The competitor (me), sat on a solitary chair in the middle of

the darkened stage under a flood light whilst the panel fired questions.

I can only remember one of those questions. With a smile that told me I was doing well, the owner of Lions Laboratories asked me if my house kits were expensive. His smile broadened to a grin when I replied that in conjunction with a well known finance company we could offer schools, a miniature mortgage.

We won first prize in this national business competition.

'Whoopee!" I can hear you say. Part of the first prize was a substantial financial package plus the secondment of an industry expert to help us for a year. The expert would be paid for by the taxpayer and best of all, to my mind, a two week residential business intensive with six top business professors including one from Harvard business school, USA. Sadly *'whoopee'* didn't describe how I felt at the time.

Jim Rohn asks the question, *'If a friend accidentally puts poison in your coffee or an enemy purposely puts poison in your coffee which is worse? Neither, they are equally bad for you. The business moral is, 'watch your coffee!'*

I had acquired a business partner. His investment had been welcome at the time. Unbeknown to me this new business partner was a member of the 'Welsh Mafia' and was quietly arranging the accounts so that he could wipe me out and run off with everything.

I was busy working *on* my business instead of *in it* and I had gone to London. I went to see the people at The British Design Council in the Haymarket. I got on with them like a house on fire. They advised me what I would have to do in order to get my products before

their selection committee.

I went back to my factory on the marshes and although I had been asked for 10 X 8, glossy black and white photos and a description of what my company made I decided to send at least one coloured photo because the products we made were just so photogenic and a black and white would not have done them proud.

Within a couple of days of receiving my coloured photo they dispatched their own, professional photographer from London.

One of the photos he took became the cover photo for the Design Council's A4 magazine "Engineering Design Education." There was a three page article with other photos of our materials.

We were finalists in the national TV competition. We had begun to sell to Universities as well as schools and colleges. I had completed writing a children's book called the 'Miniature Brick Company' and now we were becoming the toast of The Design Council. My head was spinning. The book was going to lead us into merchandising to children; toys!

We were already having discussions with Tonka about a 'building site kit' with prefabricated concrete slabs and part built brick walls. They also wanted truck loads of bricks made and packed on pallets, proportional to their bright yellow, steel toys.

Our first export load of bricks was warehoused at Liverpool Docks, when a twelve week national dock strike immobilised them.

Dark clouds were gathering. Whilst all this was going on my business partner was busy shifting money

out of the business and selling us down the river.

Without warning me, the bank froze our assets and I heard of this calamity just two days before the final episode of the national business competition.

I had just delivered the biggest single order we had made to date, to Lincoln University.

The partner had walked away with most of our cash and because he was an accountant the bank had believed him when he had told the manager that our business was in financial trouble through my mismanagement.

The Saturday that I walked out under the spotlight and sat in the hot seat you have no idea how much was going through my head as I strove to answer the cross fire of questions.

(It took me five years to pay off the debts we incurred when our money was stolen and that exercise put the last nails in the coffin of my first marriage.)

We won the competition and a pile of money but the first business was dead.

The MBC Ltd. morphed into the Miniature Brick Works. We moved to an industrial estate and left the lovely factory with its lousy memories behind us.

To cope with the peaks and troughs of the sales cycle, (most schools ordered in April-May), I designed equipment to make larger bricks.

These, larger bricks would become fund raising, novelty, and promotional bricks. The idea came to me when I saw a local church collecting to build an extension to the church hall.

They had a thermometer board showing how much they had collected. As a brick manufacturer, what

grabbed my attention was their promotional message. 'Buy a brick for the hall'. Not an inspiring message for most people but it hit my mind like a bolt of lightning!

No matter what I did that day the words kept bouncing around my brain. Then out of the mental irritation came the idea. Make bricks that could be used as paperweights and print fundraising slogans on the brick, such as 'I bought a brick for the church hall' and then put a green baize patch on the bottom of the brick. Voila, printing money!

If the bricks were a pound Stirling each the church could have 50p, we would get 50p and the prospect would get something that was useful, decorative, and fun to look at. It would also tell the world about the prospect's generous contribution to the church. 'I bought a brick for St Joseph's church Hall' etc printed on each brick.

Our slogan for the fund raising and promotional bricks was; 'give them something to talk about.' The bricks were just a bit larger than a Lego Duplo brick (See photo).

Our new range of bricks was to be printed upon. So they had to have a shiny surface after being fired

Our promotional, novelty and fundraising bricks was our best invention. In the first nine months we made more money from these than from the total income from the previous five years with the smaller brick

I will just mention some of the highlights here because the many and varied customers would be tedious to recall and anyway we made so many I can only remember the interesting ones. We sold to County

Cricket Clubs (for fund raising), builders, architects and real estate franchisees of course.

The quirkiest promotional brick we ever made was for a Liverpool taxi company called Cavalier Cabs! We sold a thousand bricks to that firm. Each had a screen printed copy in full colour of the Laughing Cavalier and the details of the cab company in black on the back. I am still amazed at the idea that a cab company would buy bricks as promotional products.

The novelty bricks were my favourite products. We made stacks of printed bricks for the myriad London souvenir shops.

The first novelty brick we produced had the Scottish flag in full colour and on the back the legend 'It's no the size of the prezzy that counts.' Miniature bricks are still a really good idea and if you understand ceramics you might well be tempted to emulate the idea because no one else has.

There is a company cutting real brick into smaller pieces and one that makes stick on slivers of brick for model makers. There are companies making bricks out substances other than brick. None of the above had the visual fidelity required either for the educational market or the commercial model making market. This is a huge market and includes Museum display models, demonstration models for builders, miniature railways at entertainment venues etc.

Should you be tempted down this route be aware that making miniature bricks on a large scale is very difficult due to problems associated with the abrasive nature of clay and the need to maintain precise dimensions.

Full sized bricks vary by one or two millimetres, you can't do that with tiny bricks.

Unless you are extremely well funded don't be tempted to start a manufacturing business such as the brick works. You may not be able to resist the temptation to pursue a dream. I know what that feels like. If you are seriously tempted, before you succumb make absolutely sure that the significant other in your life is with you 100%. The trials and losses and incredible hours that you will find yourself putting in to your dream will destroy any but the soundest of relationships.

The brick works destroyed my marriage and the divorce destroyed my interest in the brickworks.

There are a minority of people who are creatively gifted. There are a minority of the population who walk to the beat of their own drum. Most of the rich people in the world fall into one or both of those categories.

You are one of them, have you the courage to cast aside the triumphant blanket of mediocrity and make your own destiny?

Reading won't do it but reading and learning and doing will.

You don't have to be brilliant. You just have to be better than average and then make a move from the comfortable to the exciting.

I cannot stress boldly enough how much change can be wrought in a life by action.

"Success comes through action taken in response to inspiration, or action taken in response to desperation and if this presentation doesn't inspire you, I hope a truck comes down your rut!"

I remind myself when ever I need to, of that saying by Jim Rohn. My other favourite saying, also by J R is; "life is risky, none of us are going to get out of this alive."

So take a few risks. Execute some action, action can change everything.

This book has not been about how to become an artist; it has not even been about becoming rich. It has been about how to make good, regular money from painting and other forms of art and about showing how an artist discovered ways of making painting and sculpting pay handsomely.

Everywhere we see rich and poor living side by side, in the same environment and often engaged in the same vocations. When two persons are in the same locality, following the same vocation and one gets rich whilst the other remains poor, we can deduce that getting rich is not, primarily, a matter of environment.

Some environments may be more favourable than others, but when two persons following the same vocation and in the same neighbourhood, and one gets rich whilst the other remains poor it indicates something that one should note. Getting rich is simply, and always, the result of doing certain things certain ways, on a regular basis.

If getting rich is the result of doing things a certain way and if like causes always produce like results, then any man or woman can do things in that way and become rich.

If the certain things mentioned and the ways of doing them were perhaps too difficult for all but a few then perhaps it would only be the very clever who

could aspire to become rich.

We can however observe that talented people get rich and those that lack talent get rich. Highly intelligent people get rich and also stay poor, stupid people get rich and stupid people also stay poor, the strong get rich and the weak get rich.

Artists are not plagued by the desire to get monetarily rich. They have rich lives to live anyway. Artists who do get monetarily rich, however, can become more influential artists. I think that art is naturally pursued at least in part to influence others, even if those others are stone-age hunting parties.

The book I am currently working on is how to turn an art income, into an art fortune and help others in the process. It is a book about the next step. This is the step where one moves from making a good income from art to the deep realisation that we have a right to be rich and what that implies and empowers us to achieve. It is not a book about satisfying greed. Bill Gates is not a greedy man but no one would deny that he is a rich man in every sense of the word.

Having discovered the excitement and satisfaction that comes from creating an income from your art you might have recognised that feelings engendered by success make further successes easier to achieve.

The saying that success breeds success celebrates this phenomenon but what it fails to do is to examine the mechanism that ensures success, the mechanism in the human psyche that ensures success once it is recognised and utilised.

It is clear that one doesn't have to succeed in order to have further successes. That would be a catch 22

situation and would imply that success only came to those who had already succeeded.

During my many experiences of success and of failure I began to suspect and then to recognise that success and riches are there for the taking to anyone who can prepare there selves adequately to receive.

"Ask and it will be given to you, seek and you will find," is a daunting promise that has been made with total conviction.

As you may imagine I have dwelt a great deal upon what my state of mind was when things flowed into and enriched my life and also when the flow seemed to dry up.

I came to a very exciting understanding. I am devoting a whole book to the how to and the how not to of success.

Check out my website for details of my latest book: **'Right to riches'.**